A GUIDE to Historic Marietta OHIO

A Guide to Historic Marietta, Ohio

Lynne Sturtevant

Published by The History Press
Charleston, SC 29403
www.historypress.net

Copyright © 2011 by Lynne Sturtevant

All rights reserved

First published 2011

Manufactured in the United States

ISBN 978.1.60949.276.2

Library of Congress Cataloging-in-Publication Data

Sturtevant, Lynne.
A guide to historic Marietta, Ohio / Lynne Sturtevant.
p. cm.
Includes bibliographical references and index.
ISBN 978-1-60949-276-2
1. Historic sites--Ohio--Marietta--Guidebooks. 2. Historic sites--Ohio--Marietta Region--Guidebooks. 3. Marietta (Ohio)--Guidebooks. 4. Marietta Region (Ohio)--Guidebooks. 5. Marietta (Ohio)--History. 6. Marietta Region (Ohio)--History, Local. 7. Marietta (Ohio)--Biography. 8. Marietta Region (Ohio)--Biography. I. Title.
F499.M3S87 2011
977.1'98--dc23
2011022617

Notice: The information in this book is true and complete to the best of our knowledge. It is offered without guarantee on the part of the author or The History Press. The author and The History Press disclaim all liability in connection with the use of this book.

All rights reserved. No part of this book may be reproduced or transmitted in any form whatsoever without prior written permission from the publisher except in the case of brief quotations embodied in critical articles and reviews.

No colony in America was ever settled under such favorable auspices as that which has just commenced on the banks of the Muskingum.

—George Washington, 1788

Contents

Introduction. A Sense of Place 9

1. History: Ancient Roots and Great Expectations 13
2. Downtown: Echoes of 1900 28
3. Harmar: The West Side 65
4. The Downtown Residential District: Mansions, Mounds and Marietta College 77
5. The Campus Martius Museum Complex: Native Americans, Pioneers and Rivermen 100
6. The Appalachian Countryside: Belpre, Scenic Byways and the Wayne National Forest 106
7. Williamstown: Fenton Glass, Henderson Hall and the Ohio River Islands National Wildlife Refuge 111
8. Blennerhassett Island: Glamour and Treason 121

Acknowledgements 135
Bibliography 137
Index 139
About the Author 143

Introduction

A SENSE OF PLACE

Welcome to Marietta, Ohio's oldest city and the first permanent settlement in the Northwest Territory.

Life moves at a leisurely pace in this small, elegant city. People take the time to smile at strangers and say hello. If you ask for directions or a restaurant recommendation, you may get a short history lesson along with the answer to your question. Mariettans are proud of the town's past, as they should be. The westward expansion of the United States started here in 1788.

Marietta's founders were confident the town had a great future. They believed it was destined to become one of the greatest cities in the West, perhaps even the capital of the new United States of America. That was not to be, of course, but in a sense, their hopes were fulfilled. Marietta evolved into a special place, a beautiful community that remembers and respects the past. Even casual visitors feel a strong sense of continuity as they walk the brick streets lined with historic homes, browse for antiques in the charming 1900-era downtown and tour the museums. The bridges that span the Muskingum River linking downtown and the west side form the largest historic district in the state. The past is indeed important.

But Marietta is not a historical theme park. It's a real town with festivals and fairs, a variety of accommodation choices, great shopping, exciting recreational opportunities, a winery, a microbrewery, trendy restaurants and a vibrant live music scene.

Whether you're planning your first visit or your twentieth, whether you're thinking about a weekend escape, a full-fledged family vacation or

Introduction

a permanent relocation, this book will help you discover the best the mid-Ohio Valley has to offer.

The first chapter provides an overview of the area's rich history starting more than two thousand years ago, when the Adena built massive earthworks on the banks of the Muskingum River. The story continues with modern Marietta's founding by an extraordinary group of American Patriots, followed by the days when grand riverboats landed at the levee; the tense pre–Civil War years of fugitive slaves, abolitionists and the Underground Railroad; and an extravagant Victorian building boom all the way to the present. You'll meet fascinating people such as visionary pioneer Rufus Putnam; backwoodsman Isaac Williams and his amazing wife, Rebecca; former pirate Abraham Whipple; disgraced Vice President Aaron Burr; plantation owner George Washington Henderson; society grand dames Margaret Blennerhassett and Eliza Putnam; and many more.

After the historical overview, each chapter focuses on a specific neighborhood or area. You'll find descriptions of the various points of interest, along with directions, hours and contact information. Maps, vintage photographs and contemporary shots will help you get your bearings.

Marietta is a fascinating town to explore, but don't limit yourself. There is much to see and do in the surrounding area. The city is located in the heart of Ohio's rural Appalachia Country, one of the most natural parts of the state. Large segments of the Wayne National Forest—Ohio's only national forest—are just a few miles away. So is one of the best drives in the United States. The twisting, turning journey through the southeastern Ohio hills described in chapter six is guaranteed to take your breath away no matter what time of year you visit.

Four special places in neighboring West Virginia are also included. Each offers a different type of experience. All are highly recommended, and none is more than fifteen miles away from downtown Marietta. Visitors travel to and from Blennerhassett Island—where Aaron Burr allegedly plotted against the U.S. government—aboard a replica of a Victorian-era riverboat. After you tour the reconstructed mansion and take a horse-drawn wagon ride, perhaps you'll catch a glimpse of the island's tragic ghost. Henderson Hall, the great house of a former slave plantation, continuously occupied by a single family until just a few years ago, is now open to the public. The Fenton Art Glass complex across the Ohio River in the heart of Williamstown includes a gift shop, a museum and artists' studios. Free tours and demonstrations are offered regularly. The Ohio River Islands National Wildlife Refuge on the

A Sense of Place

outskirts of Williamstown is the perfect place to learn about and observe birds and other animals along the riverbank.

Thanks to generations of scholars, historians, amateur photographers and faithful diary keepers, the mid-Ohio Valley's history is well documented. A bibliography will help those who want to learn more. Although several of the books are out of print, they are still available through Ohio's fine public libraries.

For those who want to dig even deeper, the Local History and Genealogy branch of the Washington County Public Library has a large collection of regional resources for in-library use. The branch is located at 418 Washington Street in Marietta. For hours and more information, call 740-376-2172 or visit www.wcplib.lib.oh.us and click on "Locations."

The Washington County Historical Society (WCHS) also maintains a marvelous archive of photos, documents, rare books, maps and other items. Its office is located at 346 Muskingum Drive in Marietta. For more information about the society and its resources, visit www.wchs-ohio.org or call 740-373-1788.

For up-to-the-minute information on hotels, bed-and-breakfasts, restaurants, festivals, special programs, shopping, seasonal events and tours, contact the Marietta–Washington County Convention and Visitors Bureau at 740-373-5178 or 800-288-2577, or visit www.mariettaohio.org. You can also find it on Facebook.

And finally, please feel free to contact me at www.hiddenmarietta.com or visit me on the Hidden Marietta Facebook page at www.facebook.com/pages/Hidden-Marietta. I'd love to hear from you.

1
HISTORY

Ancient Roots and Great Expectations

On a frosty, gray November morning in 1787, a group of Revolutionary War veterans gathered in Ipswich, Massachusetts. As snow filled the air, the men boarded oxcarts and set out on a long and difficult journey into the western wilderness. They intended to reach their destination, the confluence of the Ohio and the Muskingum Rivers, by the following spring. They called themselves the Ohio Company of Associates, and their leader was a solid, steady man named Rufus Putnam.

Born in Massachusetts in 1738, Putnam had fought in the French and Indian War and worked as a farmer, a millwright and a surveyor. An American Patriot, he joined the army mere hours after the Revolution's first shots were fired at the Battle of Lexington. The fortifications he designed for the Continental army helped secure several key victories. After the war, he was instrumental in obtaining land grants in the western wilderness for veterans, including the members of the Ohio Company.

Those who set out that cold November day were not fortune hunters or adventure seekers. They were men on a mission, men who shared Putnam's optimistic vision of the future. They planned to establish a town in the wilderness. Their shining city would rise out of the primeval forest, a beautiful town with broad avenues and grand public spaces; a planned community that others would envy and emulate; a beacon of culture whose light would draw settlers westward by the thousands.

When the Ohio Company men reached the Ohio River in western Pennsylvania, they boarded an assortment of rickety vessels that defy

description and set sail. Rufus Putnam led the way in a flat-bottomed boat called the *Adventure Galley*.

The Ohio Company overshot its destination. The mouth of the Muskingum was obscured by thick vines, low-hanging tree limbs and swirling river mists. If sentries at Fort Harmar hadn't called out to the passing boats, it's hard to say how much farther the flotilla would have gone before realizing its error. The spring currents were strong and swift, but Putnam and his associates managed to reverse course. On April 7, 1788, the pioneers climbed ashore near the present site of the Lafayette Hotel and founded the first permanent settlement in the Northwest Territory. They named their new town Adelphia, which means "the brethren." But Adelphia didn't seem right, and a few months later, the Ohio Company decided to select a new name for the settlement. Candidates included Castrapolis, Protepolis, Urania, Tempe, Genesis, Montgomery and Muskingum. The group chose Marietta, which was French queen Marie Antoinette's nickname. They wanted to honor her for supporting the American cause during the Revolution. Ironically, Queen Marietta was executed by French revolutionaries less than six years later.

Discovering a Lost Civilization

Shortly before they left New England, the members of the Ohio Company learned that the site they had chosen for their new town included several mysterious ancient structures. In 1787, Captain Jonathan Heart, who was stationed at Fort Harmar, caused a sensation by publishing an article about what came to be known as the Marietta earthworks in a scientific journal. The article included Heart's map of the enormous mound complex, with its 35-foot-tall conical pyramid surrounded by a moat, flat-topped square pyramids with access ramps, two huge enclosed plazas, dozens of small mounds and a 150-foot-wide walled, elevated passageway that ran an astounding 680 feet from the banks of the Muskingum River to the largest plaza.

The public was captivated by the romantic notion that an advanced civilization had lived in the North American wilderness centuries before European contact. Who were these mysterious master builders? Popular candidates included the lost tribes of Israel, refugees from Atlantis, "Hindoos," the Irish and stragglers from the De Soto expedition. Among our enlightened founding fathers, only Thomas Jefferson thought the ancestors of native people had built the Marietta mounds. His opinion was roundly rejected. The Indians were believed to be ignorant savages who clearly

History

lacked the skills to build such magnificent structures. Their ancestors were probably even more primitive. The idea that they had anything to do with the Marietta mounds was preposterous. So the thinking went. The fact that the tribes living in the area in the late 1700s—the Delaware, Wyandot and Shawnee—had no idea who had built the mounds only added to their allure.

Today, we know the earthworks were constructed over several centuries by two groups of Mound Builders. Approximately twenty-five hundred years ago, the first group, a mysterious people known as the Adena, migrated into the valleys of the Ohio River and its tributaries. They lived peacefully in the area, building their earthen structures, for about five hundred years. About the time of the birth of Christ, evidence of a new, more sophisticated group of Mound Builders begins to appear in the archaeological record. The newcomers are called the Hopewell. Scholars do not think the Hopewell conquered the Adena. They believe they were simply a later phase of Adena culture; the same way contemporary America is a later phase of the culture that produced Rufus Putnam.

The Hopewell added on to the Adena mounds, creating the enormous Marietta earthworks complex. At certain times of the year, such as solstices and equinoxes, archaeologists believe thousands of people converged on the mounds. The gatherings were primarily religious in nature, but feasting, dancing and trade undoubtedly took place too. Ancient people came to the earthworks for more than one thousand years before abandoning them for unknown reasons.

When Rufus Putnam saw the earthworks for the first time in the summer of 1788, there were more than ten thousand mounds in the Ohio Valley. Fewer than one thousand remain. The Marietta complex survived because of the actions taken by the Ohio Company. They did not know how old the mounds were or who had built them. They did know the earthworks were important.

Putnam gave the largest features grand Latin names. The tall pyramid was christened Conus because of its conical shape. He named the smaller of the two flat-topped pyramids the Capitoleum after one of ancient Rome's seven hills. The larger platform mound became the Quadranou. The walled corridor from the banks of the Muskingum River was named the Sacra Via, which means "the sacred way." Marietta's founders then set the ancient monuments aside as public parks. Conus and the area surrounding it later became Mound Cemetery.

The Marietta earthworks have deteriorated to some extent over the last two centuries. The Washington County Public Library sits atop one of the

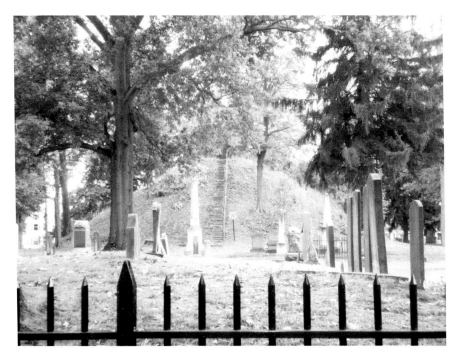

The great mound Conus rises from the center of Mound Cemetery. *Photo by Michael Pingrey.*

platform mounds, and the magnificent walled walkway that led to the banks of the Muskingum River is nothing more than a gentle rise in a few front yards. But thanks to the foresight of Rufus Putnam and others, a significant amount of the complex is still here, available to anyone who wants to explore the ancient magic. The remaining earthworks are described in detail in chapter four.

LAYOUT OF THE EARLY CITY

Rufus Putnam and his associates were planners. They had no intention of allowing Marietta to develop haphazardly. Even before they left Massachusetts, they had made many critical decisions about the settlement and committed them all to paper. The streets were laid out in a grid pattern. North–south streets were given numbers; east–west routes were named after heroes of the American Revolution, men with whom the war veterans had served and knew well: Washington, Wooster, Scammel, Montgomery, Butler

History

and Greene. Washington Street was to be Main Street, which is why it is the widest street in town. Even though Washington Street did not evolve as Putnam hoped, the basic layout survived. The Ohio Company's grid is the street plan of Marietta today.

In the first years, however, the carefully planned city existed only in the founders' minds. People clustered in three separate areas. The army was housed in Fort Harmar on the west bank of the Muskingum River. The fort, which is where the eagle-eyed sentries who spotted the Ohio Company flotilla were stationed, was built in 1785. Troops were sent to the mid-Ohio Valley to control white squatters who were building on Indian land in violation of several treaties. Nothing remains of Fort Harmar today. It stood approximately where Harmar Elementary School is now located. See chapter three on Harmar for more information.

A small group of settlers huddled in rough log cabins near the current location of the Lafayette Hotel. The area was known as Picketed Point because they surrounded their cabins with a tall stockade fence made of pointed timbers to protect themselves from Indian attacks.

The majority of people lived in or around Campus Martius, a large and impressive fort that contained block houses, spaces for public meetings and religious services, private homes and a parade ground. It sat on the eastern bank of the Muskingum River about one mile north of Picketed Point. At the first sign of trouble, those living outside the fort's walls rushed into Campus Martius for protection. The Campus Martius Museum on the corner of Second and Washington Streets occupies a portion of the old fort's grounds. The museum was built around Rufus Putnam's house, which, incredibly, still exists and is open to museum visitors. The Ohio Company Land Office, the oldest building in the state, is also part of the museum.

Regardless of which "neighborhood" they chose, Marietta's earliest citizens lived in difficult and primitive conditions. They struggled through epidemics, famines and destructive storms. There were plenty of horrible ways to die, but for many, the most terrifying aspect of life on the frontier was the ever-present threat of an Indian attack. Escalating hostility between Native Americans and white settlers marked by incredible savagery on both sides erupted into a full-fledged war in 1790. The confederation of Indian tribes was defeated by troops under the command of "Mad Anthony" Wayne at the Battle of Fallen Timbers in northwestern Ohio in 1794.

A Question of Geography

With the threat of Indian attacks eliminated, Marietta's founders were certain hundreds of settlers would flock to the new town. They didn't. Those interested in farming settled farther west in the rich bottomland along the Scioto and Miami Rivers. Fortune hunters, land speculators and adventurers continued downriver to the more exciting settlements at Cincinnati and New Orleans and the wide open spaces of the far West.

Marietta's geography was part of the problem. Not only was most of the immediate area unsuitable for farming, but also the steep ridges that encircled the town precluded much physical expansion. And then there were the rivers. Rivers were the main transportation routes in early America, and although the Ohio and the Muskingum carried people, goods, money and ideas, they were also the bearers of death and destruction.

The first serious flood occurred in 1790, only two years after the town's founding. Muddy river water seeped into the settlement with startling

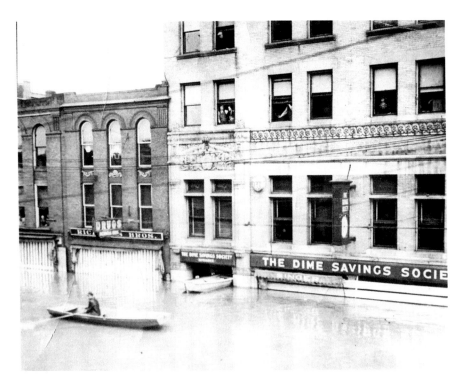

The Riverview Building at 100 Front Street during the 1937 flood. *Courtesy of the Washington County Historical Society.*

regularity. Spring and autumn were—and still are—particularly dangerous times. The Shawnee who lived in the valleys of the Ohio River and its tributaries in the late 1700s knew not to build on the flood plains. They warned Marietta's founders about the rising waters, but the settlers ignored their advice and constructed Marietta mere feet from the banks of both the Ohio and the Muskingum Rivers.

Westbound settlers were not willing to move to such a flood-prone area when so many other good, dry places were available. To complicate matters, the frequent epidemics and fevers that wracked Marietta's population, coupled with the hot, humid summers, convinced many that the town was little more than a disease-ridden swamp.

Even given its unfortunate reputation as a damp and "sickly" place, Marietta's population continued to grow, albeit at a much slower pace than Putnam and his associates had hoped. Those who chose to settle in Marietta were proud of their town. They believed it had a promising future. A few taverns and retail establishments opened on the Ohio waterfront, and families began to build small homes along the dirt streets named for the Revolutionary War heroes.

Marietta's founders put great value on public education. In the earliest days, classes for children were held in Campus Martius. Instruction was also offered at the Point and in Fort Harmar. In 1797, Marietta's citizens agreed the town needed an official school, and they began raising money. The Muskingum Academy, the first school in the Northwest Territory, opened in 1800. The pupils studied reading, writing, arithmetic, geography, English grammar, Latin and Greek. The school building was located on Front Street, about halfway between Putnam and Scammel Streets, approximately where the Congregational church is today.

Things were looking up, but even the most optimistic residents knew that in order for the town to survive, Marietta had to differentiate itself. Its citizens needed to find or create something new and different—a crop, a raw material of some sort, a finished product or an unusual service—something unique and appealing enough to change the town's image and draw people and money to their doors.

An Incredible Idea

As the old cliché goes, desperate times call for desperate measures, and the leaders of the Ohio Company were up to the challenge. Not known for small thinking, they came up with a spectacularly improbable idea. They planned

to transform the tiny settlement into the premier shipbuilding center of North America. Never mind the fact that Marietta was located hundreds of miles from the sea. The fine vessels constructed from local wood, a plentiful and cheap resource, would sail proudly down the Ohio, take a left at the Mississippi and continue south to the Gulf of Mexico, the open ocean and the markets of the world. The only thing more amazing than the audacity of their plan was the fact that they pulled it off. Their success was due, in no small measure, to the man selected to command the first ship.

Abraham Whipple was a flamboyant and charismatic adventurer. Born in the Rhode Island colony in 1733, he became a ship captain in his twenties. During the French and Indian War, he was a privateer. The only difference between a privateer and a pirate was that the privateer had government authorization to capture, burn and plunder enemy ships. Privateers kept a portion of the loot they seized as pay. Abraham Whipple was a skillful, fearless and very successful privateer. He made his name by capturing twenty-three French ships in seven months, a record at the time.

Whipple served in the Continental navy during the Revolutionary War and fired the first shot at the British navy on behalf of America. He was bold, clever and often used trickery to outfox his foes. In 1779, while sailing off the coast of Newfoundland, he spotted the Jamaica Fleet, a group of 150 British ships sailing together. He immediately raised a British flag and slipped into their midst unnoticed. After sailing along for a few hours, he signaled a nearby ship and invited its captain to join him for dinner. As soon as the British officer was aboard, Whipple informed him that he was a prisoner of war. A small party of Whipple's sailors then boarded and seized the captain's ship for America. While searching for booty, they found the official British navy signal code manual. Creative use of the information in the manual enabled Whipple to capture 9 more vessels of the Jamaica Fleet. He sailed all 10 ships into Boston Harbor to the delight of the city's residents. At the end of the Revolution, Whipple sailed the *George Washington* down the River Thames in London with the American flag fluttering proudly from its mast. It was the first time the Stars and Stripes officially flew in Britain.

After the war, Whipple followed other veterans and migrated to the banks of the Muskingum River. In 1801, when the *St. Clair*, the first ship built in Marietta, was ready to sail, he was asked to command it. Although he was not an experienced river captain, Abraham Whipple managed to maneuver the *St. Clair* down the Ohio and the Mississippi. He thumbed his nose at Spanish tariff collectors in New Orleans and continued on to Havana, where he sold his cargo of pork and flour for a huge profit. Whipple filled the *St.*

History

Clair with sugar and headed up the East Coast to Philadelphia, where he sold the sugar, sold the ship and made more money than anyone had dared hope. He then walked back to Marietta and shared the proceeds with those who had financed the *St. Clair*'s construction. He was sixty-eight years old.

Men streamed into Marietta to work at the shipyards. Many brought their families along, and the population finally swelled. Established merchants prospered, and new taverns, rooming houses, shops and small businesses catering to various aspects of the shipbuilding trade popped up all over town. The boom ended as quickly as it began. In 1807, in an attempt to thwart increasingly violent French and British attacks on U.S. vessels in international waters, President Thomas Jefferson embargoed all American sea trade. The Marietta shipyards fell silent. Once the embargo was lifted, a few more ships left Marietta to sail the world. But for all intents and purposes, it was over.

Incredibly, there was a resurgence of boatbuilding in Marietta in the 1840s. But the vessels produced in Marietta's shipyards the second time around were not oceangoing sailing ships; they were steamboats designed to ply America's rivers. Once again, the population grew, and businesses of all sorts flourished. It seemed that Rufus Putnam's planned city was finally starting to thrive. Unfortunately, he did not live to see it. Putnam died in 1824.

The 1830s and '40s were a time of consolidation and civic improvements in Marietta. Marietta College, one of the oldest and most respected private educational institutions in the country, was chartered in 1835. About the same time, the walls of the Sacra Via, the ancient Hopewell corridor that led from the banks of the Muskingum River to Third Street, were taken down. The clay they contained became bricks, which were in great demand as new buildings and homes appeared all over town.

City leaders attempted to impose order on the chaos that was Mound Cemetery by hiring caretakers, adding pathways and instituting a record-keeping system. They also removed about five feet of dirt from the great mound Conus, which gave it a flat rather than rounded top. Stairs were added to protect the ancient structure and to make reaching the observation deck easier. The top of the mound became the ideal place to gaze out over Marietta. The view from Conus was of a city in transition.

Ohio Street, along the Ohio riverbank, was Marietta's first Main Street. But by the 1830s it was well on its way to becoming the seediest street in town. It was lined with businesses catering to those who worked on the river, including boat repair services, wholesalers of various sorts and an increasing number of bars, bordellos and flophouses. There was no shortage of customers for the establishments along Ohio Street, although few members

Architect John Slocomb added "Slocomb spires" to many of his buildings, including the Unitarian church. *Photo by Michael Pingrey.*

of Marietta's upstanding and increasingly prosperous middle class would dream of setting foot there. They and the merchants who served them were migrating to Front Street, where a new business and commercial zone was rising from what had been a marshy pasture.

The 1830s also saw the arrival of the man who designed several of the area's most beautiful buildings, John Slocomb. On census records, Slocomb listed himself as a carpenter, but he was much more than that. He was a talented and successful architect who specialized in the Gothic Revival and Italianate styles so popular at the time. He was also a civic-minded person. He was elected to the Marietta City Council, was president of the Washington County Agricultural Society and served in the Home Guard unit known as the Silver Grays during the Civil War. John Slocomb's notable buildings include the Castle, the Anchorage, the Unitarian and Episcopal churches in Marietta and Henderson Hall in nearby West Virginia. Each is described in detail in later chapters.

History

Slavery, Freedom and Preserving the Union

Although few would have disputed the Ohio River's importance as a commercial waterway, by the mid-1800s, the river had also taken on a symbolic significance. At a critical point in the book *Uncle Tom's Cabin*, the Ohio freezes, allowing the slave Eliza to escape across its surface. Called the "River Jordan" by fugitive slaves, it represented the boundary between freedom and servitude.

Slavery had been illegal in the Ohio Country from the very beginning. It was outlawed by the Northwest Ordinance of 1787. But everyone living in the region did not agree on the issue. In 1802, when delegates gathered in Chillicothe to draft a constitution for Ohio, a necessary step toward official statehood, the debate over slavery was intense and bitter. The delegates found themselves evenly divided. Washington County judge Ephraim Cutler, a vocal and committed abolitionist, was too ill to attend the convention. However, when he learned that the delegates were deadlocked on the issue of slavery, he asked Rufus Putnam and Henry Fearing to carry him to Chillicothe. Judge Cutler cast the vote that broke the tie and kept Ohio free.

Rufus Putnam and the New Englanders who settled Marietta were opposed to slavery on moral grounds. Yet their little town stood directly across the river from old Virginia, with its plantations and slave markets in Parkersburg, Wheeling and St. Mary's. As early as 1816, local people were helping slaves escape, a very dangerous proposition. Even though Ohio was a free state, escaping slaves captured here could be returned to their owners. Runaway slaves were not truly safe or free until they reached Canada. If caught, those who aided them were subject to stiff fines and imprisonment.

The network of people, churches and communities who protected fugitive slaves and helped them find their way north is known as the Underground Railroad. Although tunnels were occasionally used as hiding places, "underground" refers to the network's secret nature. For the safety of everyone involved, almost nothing was documented. We do not know how many people escaped. Estimates range from 10,000 to more than 100,000.

Underground Railroad activity was especially intense in the 1830s and '40s. Many Washington County residents were involved. They hid fugitives in barns, woods and secret rooms and helped them travel at night. The main local route to safety was called the Muskingum Line. It went from the Ohio riverbank north to Lake Erie.

Washington County efforts were directed by a Marietta man, David Putnam, a descendant of Rufus Putnam's brother. Putnam sent his agents—as

those who worked on the railroad were known—to the banks of the Ohio to wait for boats. Several times a month, an elderly slave named Josephus manned the oars of the boat that silently slipped across the river. Josephus ferried an unknown number of men, women and children from the outskirts of Williamstown to a point on the Ohio shore near the present Interstate 77 Bridge. He then rowed back to the Virginia side and returned to his plantation. His owners were never aware of his nighttime journeys, and we do not know the name of the plantation where he was held.

The Washington County conductors and agents of the Underground Railroad almost never routed fugitives through Marietta. The chance of detection and capture was too high. However, sometimes plans fell apart, and they had to enter the city with their "cargoes" of fugitive slaves. In these rare cases, they knocked on the door of one of two emergency safe houses. The first was located at 508 Putnam Street, on what is now the Marietta College campus. The house was torn down in 1964. The other safe house was David Putnam's residence in Harmar, truly a place of last resort. Putnam's house was under constant surveillance by the Copperheads, proslavery forces. It stood near the Anchorage, which was owned by his brother, Douglas. David Putnam's house was torn down in 1953.

David Putnam went to jail a few times for his antislavery activities, and in 1847, he was sued in federal court in Columbus by George Washington Henderson, whose slaveholding plantation, Henderson Hall, was less than five miles from Putnam's house in Marietta. Henderson accused Putnam of violating various laws by inciting and helping his slaves run away. After dragging on for several years, the suit was dismissed. The animosity between the two men, however, never dissipated. For more on the Henderson family and their plantation house, which still stands and is open to the public, see chapter seven on Williamstown.

Many citizens of Belpre, eleven miles west of Marietta and directly across from Parkersburg, were particularly active in the Underground Railroad. The inhabitants of a large white house on the riverbank placed a light in a second-story window when it was safe to cross. Countless people found their way across the dark water by rowing toward that light. The Farmers' Castle Museum and Education Center in Belpre includes a large permanent exhibit on the Underground Railroad in southeastern Ohio. For more information on the museum, see chapter six.

Just as not all Ohioans supported the cause of freedom, not all Virginians favored slavery. And some Virginians who supported slavery did not support secession. They believed in preserving the Union. After Virginia voted to

History

join the Confederacy and secede from the United States, delegates from the northern and western parts of the state, including George Washington Henderson of Williamstown, gathered in Wheeling in 1862 and voted to secede from Virginia. The new state of West Virginia was officially admitted to the Union in 1863.

Many of the mid-Ohio Valley's young men died fighting to preserve the Union. A few fought for Dixie. In West Virginia, about half the population sympathized with the North and about half with the South. Despite constant rumors that Confederate raiders were in the area poised to burn Marietta and Williamstown, both communities survived the conflict physically unscathed.

Oil and Gas and the Twentieth Century

Native Americans and the earliest white settlers knew there was oil in the area. In many places, it seeped to the surface forming sticky black puddles of asphalt. Enterprising individuals soaked up the viscous oil in blankets, wrung it out, strained it, bottled it and sold it to pharmacists. The pharmacists then resold it as Seneca Oil, a cure for everything from skin ailments to rheumatism. Oil wells began appearing as early as the 1820s, but petroleum did not fetch a high price. Its main use was as an industrial lubricant.

By the 1890s, however, the demand for petroleum was growing, and the realization that there were vast quantities of oil and natural gas in the Ohio and West Virginia hills sparked the biggest economic, population and construction boom in the region's history. Many of the buildings that make Marietta so visually appealing today were erected then. Oil and gas profits financed the lovely homes that line Third, Fourth and Fifth Streets. Commercial buildings of three and even four stories—some equipped with "sanitary" toilets and elevators—rose on Front, Second and Putnam Streets. The steamboats were being replaced by steam locomotives. Marietta became quite a railroad hub with dozens of passenger and freight trains pulling into its elaborate stations each day.

In 1900, the board of trade published a booklet called the *Century Review of Marietta, Ohio*. Even though its authors promised not to indulge in "excessive personal effusions," the slim volume overflows with optimism and civic pride. In 1900, it was hard to imagine what could possibly go wrong. Marietta finally appeared to be on course to become the important city that Rufus Putnam and his associates had envisioned in 1788. But once again, it was not to be.

A vintage railroad car in Harmar. *Photo by Michael Pingrey.*

By the time the United States entered World War I, the Marietta oil boom was over. The oil company executives, their free-spending wives and the men who had worked on the wells were gone. Very few trains and even fewer passengers were stopping at the big Union Railroad Depot on Second Street. The city, so confident about its future less than twenty years earlier, had become what railroad workers called a switched-off hick town.

Marietta was a typical small river city during the early years of the twentieth century. World War II brought a short-term economic boom in the form of defense contracts. Women went to work as local men were sent to Europe, North Africa, Asia and the South Pacific to fight. Some never came home. Many of those who did return were forever changed. When the war ended, life in Marietta returned to normal. It was once again a pleasant, quiet—some would say dull—place to live.

From the beginning, Marietta's leaders had tried to make the town an important, influential place, a city of substance and class. There were still people who had that dream. But a subtle change had taken place. Maybe it grew out of the war experience, going to other places, seeing the way other

people lived. Whatever the reason, most of Marietta's citizens had come to the conclusion that the town was just fine as it was. They didn't want to be on the cutting edge of American culture. Besides, the town had a certain level of sophistication thanks to Marietta College. The streets were safe, and the lack of heavy industry meant they were clean, too. To those who lived here, Marietta was more than fine. It was wonderful.

Civic leaders began to wonder whether Marietta's history, brick streets, beautiful rivers, elegant turn-of-the-century homes and small-town atmosphere might appeal to tourists. At the height of the oil boom, there were dozens of hotels, boardinghouses and other establishments catering to temporary workers and transient men, as traveling salesmen were then known. But the idea of actively promoting Marietta as a leisure destination was new.

Marietta's citizens liked the tourism idea. They were proud of their town and looked forward to sharing it with visitors. But the obstacle that had stalled Marietta's progress in the past arose once again. The town's geographic location and isolation were major hurdles. After several fits and starts, Marietta finally blossomed as a tourist destination in 1968, when the local segment of Interstate 77 opened.

Today, Marietta is one of most visited and beloved towns in the state. Many return year after year to shop, stroll the lovely brick streets and relax in a wide variety of bars, coffee shops and restaurants. Active folks kayak on the rivers, camp and hike in the nearby Wayne National Forest. Others ride motorcycles down the scenic country roads that snake through the surrounding hills. There are street fairs and festivals that celebrate music, food, crafts and Marietta's river heritage. But nothing draws people more than the town's history. They come to tour the historic houses and visit the museums. Thanks to the vision of Marietta's founders, those who want to reach even further into the past are free to explore the mysterious mounds and ancient earthworks. Marietta's isolation has become one of its greatest assets. It is a destination unto itself. Visitors feel as if they've entered a different world, a friendly place where the past is still alive. Rufus Putnam would be pleased.

2
Downtown

Echoes of 1900

On January 1, 1900, it was clear to everyone that Marietta's days as a "slow town" were over. The town's reputation as an isolated and unimportant place was as passé as gaslights and buggy whips. The discovery of oil and natural gas in the area had ignited an economic and population boom that showed no signs of abating. Many of the beautiful homes and elegant downtown buildings that give Marietta its character were built during this time of prosperity, opportunity and optimism.

The ground-level storefronts along Front Street do not look as they did in 1900. Businesses have come and gone; buildings have been remolded.

Victorian rooflines on Front Street. *Photo by Michael Pingrey.*

Downtown

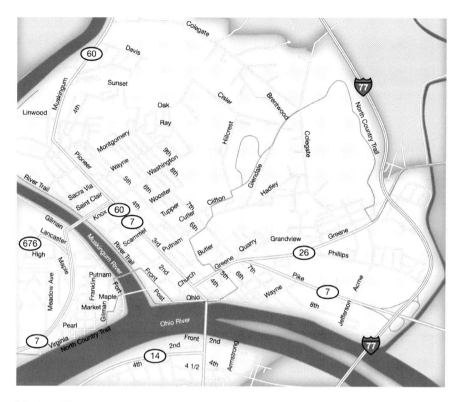

Marietta, Harmar and Williamstown map. *This image is copyrighted by the Marietta-Washington County Convention and Visitors Bureau and appears with the bureau's permission.*

Fires and floods have damaged or destroyed some structures. But many of these seemingly significant changes are actually superficial. In order to recapture the feel of old Marietta, all you have to do is look up. The rooflines, decorative elements and upper-story windows have not changed much. The faded letters of old ads cling to the brick walls, cryptic messages from another time promoting products that no longer exist.

THE LEVEE AND OHIO RIVERFRONT

The Levee

Marietta residents call the Ohio River waterfront the Levee. This confuses visitors and newcomers, who expect to see embankments or walls to hold back floodwaters. There are no such structures on the riverfront. Civil engineers

have urged the city to construct flood walls for years. However, Marietta's citizens have repeatedly rejected the concept, preferring the unobstructed views of the beautiful Ohio.

Many years ago, the word "levee" also meant a landing place for boats, and its current usage in Marietta recalls that time. During the city's first century, the Levee—or the Marietta Landing, as it was also known—was a busy place with boats of all shapes and sizes unloading and taking on passengers and cargo. Today, the Levee is home to a large number of geese and ducks, a few blue herons and the occasional seagull. For most of the year, it is a peaceful place to relax and watch the river. However, each September, the Levee is transformed as riverboats arrive for the Sternwheel Festival, an end-of-summer celebration with food, music and the best fireworks around. The festival is held the weekend after Labor Day. Contact the Marietta-Washington County Convention and Visitors Bureau for details.

The Bicentennial Plaza and Fountain

The plaza and fountain are located at the intersection of Front and Greene Streets, across from the Lafayette Hotel on the Ohio riverbank. They were erected to commemorate Marietta's 200th birthday in 1988. A hexagonal-shaped concrete post topped with a boulevard light rises above the fountain. Each of the post's six sides bears the name and smokestack profile of a famous steamboat that plied the Ohio or Muskingum River.

Ohio Street

Ohio Street is the narrow brick lane running east from just beyond Bicentennial Plaza along the upper bank of the Ohio River. A single block-long segment that does not connect to the rest of the street runs along the south side of the Lafayette Hotel between the building and the parking lot. That portion of the street is discussed in the section about the hotel.

Ohio Street used to be the busiest and most important street in town. It is where Marietta's first commercial district appeared. Ohio Street was lined with dry goods stores, warehouses and businesses catering to those working and traveling on the river. All the buildings stood on the same side of the street facing the Ohio. By the late 1800s, Ohio Street had taken on a decidedly risqué atmosphere. It was home to several saloons and cheap hotels, the most successful of which housed ladies of the evening. At night, Ohio Street was crowded, noisy and a little dangerous—a combination many found irresistible.

Downtown

Ohio Street's fortunes declined as river traffic dwindled. By the mid-twentieth century, it had become an eyesore, a street of empty, derelict buildings with broken windows and leaky roofs. Slowly but steadily, the old structures were demolished to make way for the condos and open green spaces of today.

On Friday and Saturday evenings during summer and early autumn, quiet Ohio Street becomes an entertainment center once again. These days, however, the diversions are definitely of the G-rated variety. People relax on the riverbank, eat ice cream cones and listen to free country music concerts as the setting sun turns the Ohio pink and gold.

The Levee House Café

Standing alone at 127 Ohio Street, the Levee House Café is the only vestige of the wild and rowdy river days. As you face the building, you'll notice that it is actually two structures. The three-story section on the left is one of the oldest buildings in town, first mentioned in 1826. It is not clear whether it was built that year or already existed. The three-story side is devoid of decoration,

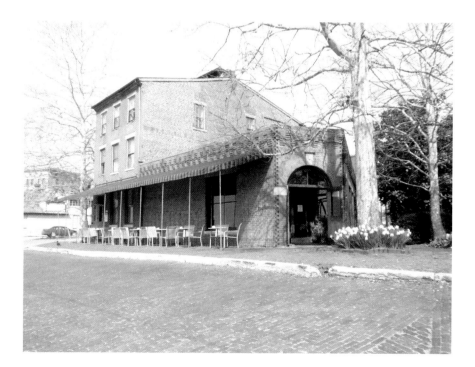

The Levee House Café on Ohio Street. *Photo by Michael Pingrey.*

which was typical of early Ohio Street buildings. The one-story section on the right was built in 1911. Notice the decorative brickwork at the roofline.

The three-story part of the building has a dark and juicy past. For several decades, it was a notorious house of prostitution called La Belle Hotel. It was the scene of a horrific murder—a young man decapitated his father with an axe in one of the bedrooms. The incident gave rise to one of Marietta's best ghost stories. Today, this portion of the old building houses apartments with unbeatable river views.

The one-story section has a colorful history, too. One hundred years ago, it opened as the Golden Eagle Saloon. The fact that the Golden Eagle and La Belle Hotel shared an interior doorway allowed customers to roam freely between the two establishments. The Golden Eagle later became a liquor store. Stand outside facing the building and look carefully at the brick wall behind the outdoor tables. You can still read the pale painted letters of the word "whiskey." On the right side of the restaurant window, it is just possible to make out the faint image of an enormous bottle with "cold beer" written across it.

The former Golden Eagle space and La Belle Hotel's parlor house a delightful restaurant. Open year-round, the Levee House Café offers the option of outdoor dining in warm weather. For reservations or information, call the Levee House at 740-374-2233.

Buckley's Island

The large island in the Ohio River between Marietta and Williamstown is known as Buckley's Island. It is home to a wide variety of waterfowl, many of which spend their afternoons on the Marietta levee. Today, Buckley's Island is an uninhabited natural area. This has not always been the case.

From 1793 until the mid-1820s, Buckley's Island was where the desperately ill went to die. Infectious disease outbreaks were common on the frontier. Once an epidemic took hold, there wasn't much anyone could do. Smallpox, yellow fever, malaria, cholera, dysentery and influenza rose up with regularity, wiping out entire families before subsiding, only to surface again. Summer and fall were the deadliest seasons.

The settlers did not understand the biological causes of the epidemics. However, they did know the fevers were highly contagious, and they were willing to do whatever it took to protect the healthy and to stop diseases from spreading. The people of Marietta and Williamstown worked together to build a Pestilence House, little more than a crude shelter, on the island.

When the inevitable disease outbreaks occurred, those who fell ill were placed in the Pestilence House and left to die.

Thankfully, the frequency of epidemics diminished in the 1830s and '40s, and the Pestilence House was torn down. For the next forty years or so, a series of families operated small farms on the island. Everything changed again in the 1890s, when the island became home to a large amusement park complete with rides, carnival attractions and cotton candy stands. Popular with families during the day, as soon as the sun went down Buckley's Island became a haven for illegal activities, including gambling and cockfighting. Beer was available for a fraction of the price charged in Marietta's many taverns. Even though the island is only a few hundred yards from the Marietta levee, it is part of West Virginia. The Marietta police had no jurisdiction, and Williamstown had no police force. The 1913 flood demolished every structure on the island, putting an end to the amusement park, as well as the other diversions. It has been the domain of ducks, geese, blue jays and squirrels ever since. Buckley's Island is part of the Ohio River Islands National Wildlife Refuge, which is covered in chapter seven on Williamstown.

Swigs, Belts and Snorts

Early Americans consumed large amounts of ale, wine and spirits. Prior to setting out for the western wilderness, Marietta's founders held most of their planning meetings in New England watering holes, such as Rice's Tavern in Providence, Rhode Island, and the Bunch of Grapes in Boston. Marietta's first Fourth of July celebration in 1788, held just three months after the town's founding, is a case in point. The revelers enjoyed grog, wine and a barrel of punch while raising their cups fourteen times to the following institutions, countries and individuals:

The United States
The Congress
The Most Christian Majesty
The United Netherlands
The Friendly Powers throughout the World
The New Federal Constitution
His Excellency General Washington and the Society of the Cincinnati
His Excellency Governor St. Clair and the Western Territory

The Memory of Those Who Have Nobly Fallen in Defense of American Freedom
Patriots and Heroes
Captain Pipe, Chief of the Delawares, and a Happy Treaty with the Natives
Agriculture and Commerce, Arts and Science
The Glorious Fourth of July
The Amiable Partners of Our Delicate Pleasures (aka their wives)

One hundred years later, there were thirty-two saloons downtown with wonderful names like the Vestibule, the Cincinnatus, the Delmonico, Whitey's and the Old Flamingo. There were also sample rooms, which were essentially bars, in most of the hotels; a major brewing operation; and a distillery, which was located at 217 Greene Street in the building now occupied by the Locker Room Sports Bar.

Complaints about excessive drinking began as early as 1810, but there were no serious attempts to restrict alcohol use until the Rose Law was enacted in 1908. It allowed voters in each Ohio county to decide whether their jurisdiction would be wet or dry. Washington County voters opted for

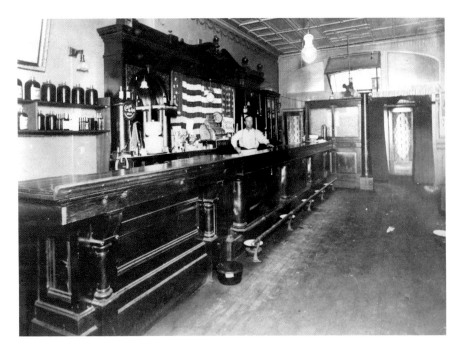

The Vestibule. The sign behind the bartender says "Positively No Treating." No buying drinks to gain votes. *Courtesy of the Washington County Historical Society.*

prohibition, and as of January 1, 1909, the sale of alcohol became illegal in Marietta. Consumption, however, was still permitted. The brewery tried to reinvent itself, but the saloons, sample rooms and distillery closed. The dry spell only lasted until 1912, but the majority of the original businesses never reopened. The new saloons that appeared to take their places had to close their own doors in 1919, when national Prohibition went into effect. After Prohibition was repealed in 1933, taverns, saloons, cocktail lounges and bars came roaring back.

Today, Marietta has a microbrewery, a winery and a thriving bar scene. Several of the most popular establishments offer live music. A fascinating artifact of Marietta's long history with alcohol is on display at the Marietta Wine Cellars at 211 Second Street. An original liquor license issued in Marietta in 1789, probably the first in the Northwest Territory, hangs on the wall. Please ask to see it.

The Point and the Lafayette Hotel
101 Front Street and Environs

The Lafayette Hotel, its parking lot on the Ohio riverbank and the Army Corps of Engineers compound on the banks of the Muskingum behind the Lafayette occupy an area called the Point, so named because it extends into and overlooks the confluence of the two rivers. People have gathered at the Point for thousands of years.

About 500 BCE, a mound-building people known as the Adena arrived in the area and began constructing earthworks of various shapes and sizes, including the massive pyramid in the center of Mound Cemetery. They were followed by the Hopewell, who expanded on the earthworks and created an enormous sacred complex, the remains of which are still clearly evident. We will never know all the reasons ancient people had for building their sacred precincts here, but archaeologists are certain the confluence of the Ohio and the Muskingum Rivers was an important factor. The Point was where the power and magic of the flowing rivers was the strongest. For more on Marietta's ancient earthworks, see chapter four.

More than twelve centuries after the Hopewell's mysterious disappearance from the area, a new group of builders arrived. On April 7, 1788, Rufus Putnam and the members of the Ohio Company climbed ashore at the Point and founded modern Marietta. During the settlement's early days,

several people built log cabins near where the hotel now stands. They also opened stores—really little more than trading posts—and taverns. It was beautiful—as it still is—but the area was becoming more dangerous by the day. Violent Indian raids were on the rise.

The Ohio Company built a large fort, which they named Campus Martius after Mars Field in Rome. Campus Martius was big enough to accommodate all the setters in case of an Indian attack. However, it was more than a mile away from the Point, too far to be reached quickly in an emergency. So the residents surrounded their cluster of log cabins with a tall stockade fence made of pointed logs. The fence served its purpose during the Indian Wars, which lasted from 1790 to 1794. The area became known as Picketed Point, a nickname that was still in use more than a century after the fence, the cabins and the hostile natives had disappeared.

In 1903, the Women's Centennial Association erected a monument to the Picketed Point residents. It is across the street from the Lafayette, only a few yards from the Bicentennial Plaza and Fountain. Follow the sidewalk along the perimeter of the parking lot. The monument stands at the bank of the Ohio River.

By 1807, the Point, with its river views, had become the most desirable area in town. Not surprisingly, one of Marietta's successful merchants decided it was the perfect spot for his new home. His brick house sat approximately where the Lafayette Hotel lobby is now. The merchant died just as his home was being finished. It became a dry goods store and eventually burned down, a common fate for buildings at the time. By the 1860s, several nondescript three-story buildings sat on the corner of Front and Greene. Over the next few decades, they housed various businesses, including a grocery store, an insurance office and a bank.

In the early 1890s, when the buildings on the corner were torn down, rumors immediately began circulating that something spectacular would replace them. The Bellevue Hotel did not disappoint. It opened its doors in 1892 with four floors and fifty-five rooms of state-of-the-art, steam-heated luxury. The Bellevue had a "fast elevator," a barbershop and a very popular bar. Rooms were two dollars a night, three dollars with meals. Its onion-domed tower dominated the Marietta skyline until a fire gutted the hotel in 1916. The Lafayette Hotel—named for the Marquis de Lafayette, Marietta's first official tourist—rose from the old building's ashes. It has been welcoming guests since 1918.

The Lafayette's riverfront location has put it in the direct line of many, many floods. Stand outside the hotel at the building's curved corner at Front

Downtown

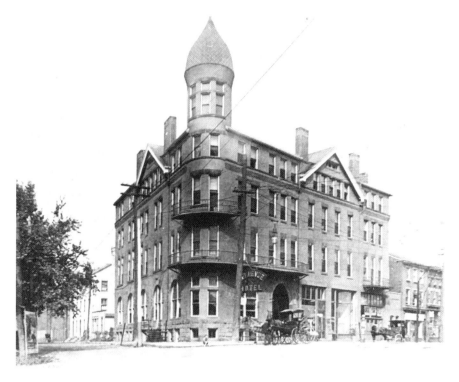

The Bellevue Hotel. *Courtesy of the Washington County Public Library.*

and Greene Streets—a feature copied from the old Bellevue—and look up. Beneath the first balcony on the Front Street side, you'll see two metal plaques shaped like the state of Ohio. They mark the high-water levels of the 1913 and 1937 floods, 1913 being higher. Rising waters don't stay outdoors, and there is another amazing flood marker in the hotel lobby.

Step inside. Stand facing the elevator. A column juts from the wall a few feet to your right. The tarnished metal plate nailed to the column's ornate painted moldings near the ceiling marks the interior water level during the 1913 flood. Vintage photos of the Bellevue and the Lafayette—including many taken during floods—decorate the lobby, which also features many beautiful pieces of Victorian-era furniture. Visitors are welcome at all times.

The street that runs along the Ohio River side of the hotel separating the building from the parking lot is an isolated portion of Ohio Street. This one-block segment, which does not connect to the rest of Ohio Street, ends behind the hotel at the entrance to the Army Corps of Engineers facility at Post Street, the oldest street in Marietta. Today, the Lafayette

fills the entire block, but for more than one hundred years, another hotel stood on the corner of Post and Ohio. Built in 1835, the Mansion House claimed to be the finest hotel in Marietta. Hotel advertising stressed the fact that it was "a house of fine character," a phrase undoubtedly intended to differentiate the Mansion House from the houses of ill repute, such as La Belle Hotel, located on the "lower" section of Ohio Street. The Mansion House was torn down in 1937. Its antique call bell system, which still works, is on display in the Lafayette. For reservations or more information on the Lafayette Hotel, visit www.lafayettehotel.com or call 740-373-5522 or 800-331-9336.

Other Downtown Hotels

According to the anonymous author of the 1900 *Century Review of Marietta, Ohio*, "The good reputation and general prosperity of a city are greatly enhanced by good hotel accommodations, for prospectors and sharp businessmen will not long remain where they are shabbily treated." Marietta has had many hotels over the years. In addition to the Lafayette, the Bellevue, the Mansion House and the ever-popular La Belle Hotel,

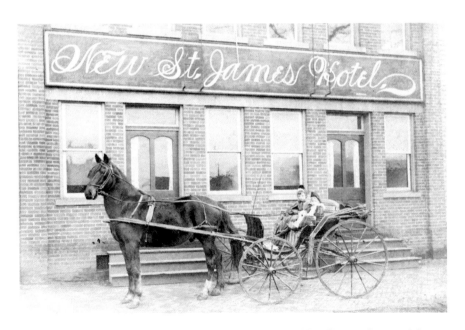

The New St. James Hotel stood on Butler between Front and Post Streets. *Courtesy of the Washington County Historical Society.*

Downtown

properties included the St. Elmo, the Norwood, the St. Cloud, the St. James, the Wakefield, the National House, the Bradford House, the Globe, the Hackett Hotel and the Exchange Hotel, which was on the west side of the Muskingum River in Harmar.

Front Street

Front Street was not Marietta's first Main Street. That honor was held by Ohio Street, as described earlier. Prior to 1830, Front Street was little more than a muddy cow pasture. Businesses began locating on Front for two reasons: 1) the town was growing and expansion was natural and 2) Ohio Street had a seedy quality that some of the town's citizens found objectionable. It wasn't long before a Front Street location became a clear advantage for businesses that hoped to attract an upscale clientele.

In the 1890s, a major building boom followed the discovery of oil and natural gas in the area. Much of the activity was focused on Front Street. As stylish brick buildings with all the latest amenities replaced dilapidated frame

Turn-of-the-century embellishments on Front Street buildings. *Photo by Michael Pingrey.*

structures, Front Street's prominence increased. Many of the buildings that line Front Street today date from that period.

There was one major drawback to locating a business on Front Street, however. It was prone to repeated flooding. The utter destruction and property loss caused by back-to-back floods in the 1880s had convinced business and civic leaders that something had to be done or the downtown growth spurt would fizzle. After much study and discussion, the city decided to undertake a major public works project and raise the level of Front Street.

Building owners watched their grand entrances and display windows disappear underground as workers dumped load after load of bricks, dirt and sand onto the street. They did not stop until the street level was one story—approximately ten feet—higher. Three-story buildings were suddenly only two stories high, and pedestrians walking along the new and improved Front Street gazed into what had been private second-story windows. Evidence of this transformation is visible in the basements, where the original ground-floor doors and windows sit in the darkness waiting for the next flood. Portions of Butler and Putnam Streets were raised too.

Front Street buildings with even-numbered addresses lie on the same side of the street as the Riverview Building, where the Chamber of Commerce is located. Odd numbered addresses are on the same side of the street as the Lafayette Hotel.

The Riverview Building

100 Front Street

For most of Marietta's past, the corner of Front and Greene Streets meant banking. In 1863, the First National Bank of Marietta was established, and work began at once on a solid yet elegant headquarters for the new institution. While construction was underway, the bank operated out of the Bellevue Hotel (the Lafayette's predecessor) across the street. By the late 1800s, the directors of the First National Bank decided it was time for an upgrade. The old bank building was razed to make way for the Riverview Building, the structure standing at 101 Front today. The Riverview, which was completed in 1902, was not only filled with modern features, but it was also an opulent and therefore suitable environment for the successful men who worked inside. Unfortunately, fire gutted the

Downtown

Riverview's interior the day after Christmas 1903. After massive repairs, the First National Bank returned to the building. The bank occupied the space until 1928, when the Dime Savings Society took over. In the 1970s, the Riverview became what it is now—an office complex with the best views in town.

Step inside. The past surrounds you the moment you enter the Riverview Building's foyer. It even smells like an old bank. Notice the worn stairs and banisters embedded in the wainscoting—all made of marble. Today, the Marietta Chamber of Commerce occupies the Riverview's second floor. It welcomes visitors during regular business hours, 9:00 a.m. to 5:00 p.m., Monday through Friday.

When you reach the second floor, pause for a moment and take in your surroundings. Look at the tile floor and the wrought-iron work on the staircase that leads to the building's upper stories. To your far left, on the wall opposite the entrance to the chamber's offices, is a vintage mail drop complete with a locked brass door and a tube that travels from the top of the building to the ground floor. Turn around and look at the large stained-glass window mounted above the main staircase. The window, part of the building's original design, is illuminated on most evenings, making it visible from the sidewalk across the street.

The double doors topped with the lovely arched stained-glass window that lead into the chamber's offices are also original. The chamber's library, formerly the bank president's office, features rich woodwork from the early 1900s. An elegant fireplace mantel from the same period is in the Customer Room.

There are three fantastic old bank vaults within the chamber's space. One of them has three sets of doors. The outer set was controlled by a time lock system. The second set was a pair of elaborately decorated iron gates. The final set of doors was equipped with a tumbler lock system. If chamber staff members are not busy, they will gladly show you the vaults. Before you leave the office suite, glance at the Ohio River from any of the windows, and you'll understand how this great old building got its name.

Brass Sidewalk Letters

100 Block of Front Street

Look down at the sidewalk as you walk north, away from the Ohio River, on the chamber side of Front Street. You will see brass letters spelling

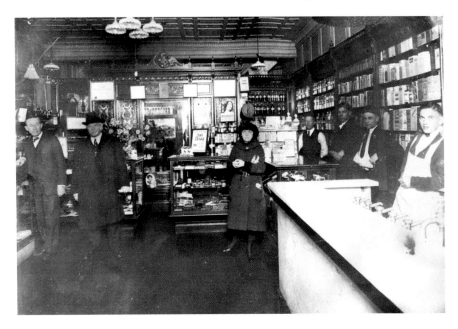

Inside Richards Drugstore on Front Street. *Courtesy of the Washington County Historical Society.*

"Richards" and a little farther up the street, near Schafer's Leather Store, "Braun" embedded in the pavement. Braun was a bakery, and Richards was a pharmacy. The gleaming brass letters are continuously polished by pedestrians' shoes as they walk up and down the sidewalk.

Double L Dance Hall and Saloon

112 Front Street

The peculiar looking building with diagonal wood siding and elaborate, columned stone entrances used to be a bank. It's now a bar.

High-Water Marks

It's hard to imagine how much water flowed through Marietta during floods. High-water marks at several spots along Front Street do more than record the flood depths; they also help us understand the magnitude of the disasters. The most dramatic display is on the corner of Schafer Leather Store at 140–42 Front Street. Look up at the building to see how deep

the water was in 1913 and 1937, the two worst floods of the twentieth century. Note the level of the 1913 flood in particular. It must have been surreal when water began pouring into the second-story windows along Front Street.

The 1913 flood still holds the record as the worst natural disaster in Ohio history. Like Hurricane Katrina, it obliterated the infrastructure that supported society. At least 468 people lost their lives, and more than 100,000 were left homeless. Property damage exceeded $2 billion in today's dollars. The misery from the twentieth century's other great flood in 1937 was intensified by the fact that it occurred in the midst of the Great Depression. Marietta was not the only town affected. The devastation from the 1937 deluge stretched from Pittsburgh to Cairo, Illinois, and left more than one million people homeless.

When you've finished contemplating the horrors of 1913 and 1937, look at the front of Schafer's building. About four feet above the sidewalk you'll see a metal plaque engraved with two horizontal arrows, the date September 19, 2004, and the words "Ivan Was Here." The arrows show the water depth of a more recent watery disaster. In early September 2004, heavy rains from the remnants of Hurricane Frances moved over the area, saturating the ground and causing the Ohio River to rise. Before the river had a chance to subside, a second storm, Hurricane Ivan, tore through Alabama and made a beeline for Marietta. Five more inches of rain brought the worst flooding in forty years.

Incidentally, Schafer's is one of the oldest businesses in Marietta. It opened in 1867 as a harness shop and has been continuously owned and operated by the same family. Five generations of Schafers have worked in the business so far. Call 740-373-5101 for more information.

Plumbers and Pipefitters Union Hall

201 Front Street

The red brick building with the angled entrance at the corner of Front and Butler Streets was Marietta's electric power plant in the 1890s. It was known as the Electric House. Two hundred electric arc lights were installed downtown to illuminate the business district. The 1900 board of trade was so enthralled with the illumination that it predicted Marietta would soon be known as "the city whose light cannot be hid." However, to save money, the lights were extinguished on nights when the moon was full. During its days

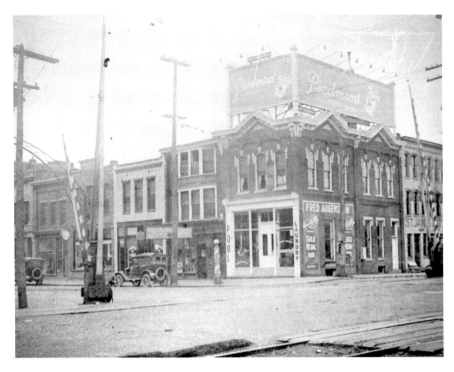

The corner of Front and Butler Streets early in the twentieth century. *Courtesy of the Washington County Historical Society.*

as the power plant, the building also served as the police station. It is now used for union activities and public meetings.

Ohio National Guard Armory

241 Front Street

The Ohio National Guard grew out of the Northwest Territory Militia, which was established in Marietta in 1788, the year the town was founded. The building at 241 Front was erected in 1914 to serve as the National Guard's local headquarters. Over the years, it has played many roles. It was the departure point for soldiers going to Europe to fight in the Great War, as World War I was then known. Throughout the conflict, Marietta's women and girls gathered in the armory to make socks, gloves and bandages for the doughboys. The armory later served as a departure point for troops entering World War II and Korea.

Downtown

The armory was used to store blankets, water, canned food and medical supplies to be distributed following natural disasters. Due to its size and central location, it was also used for community celebrations. One gray January, it became a temporary morgue after a heartbreaking nursing home fire. But the armory's main function was always as a fort. It was a repository for weapons and ammunition. In case of war, riots or civil unrest, National Guard troops were instructed to aim their rifles out of the tall, narrow windows that line the ground floor.

The Ohio National Guard vacated the premises in 1992, and the city purchased the armory in 1997. Renovation of the historic building is underway. It is the centerpiece of the Armory Square Project and will serve as a multipurpose community gathering place.

Veterans' Walk of Honor and Monument

To the right or north of the armory is the Veteran's Walk of Honor, part of the Armory Square Project. A brick walkway leads to a small plaza that contains a golden sandstone monument. Many of the bricks contain the names of those who have served in the armed forces. Two interesting items from the Spanish American War (1898) are on the display. The green metal object mounted on a stone block labeled "Relic" is a floating mine. The granite memorial that looks like a tombstone is dedicated to Spanish American War veterans.

Lockmaster's House

243 Front Street (Set Back Near the Muskingum River)

Marietta's early citizens hoped that the Muskingum River would become an important commercial artery, like the Ohio. But the Muskingum proved to be a challenge. It was prone to dangerously swift currents and spring flooding. In the summer months, water levels were often so low that navigation was impossible. In 1836, the state began a massive construction project to tame the river. Five years later, thanks to a system of eleven locks and dams, the Muskingum between Marietta and Dresden was navigable year-round. The locks were numbered from south to north, which made Marietta Lock Number One.

A lockmaster was assigned to operate each lock. The job required great physical strength because the locks were hand-cranked. The lockmaster was

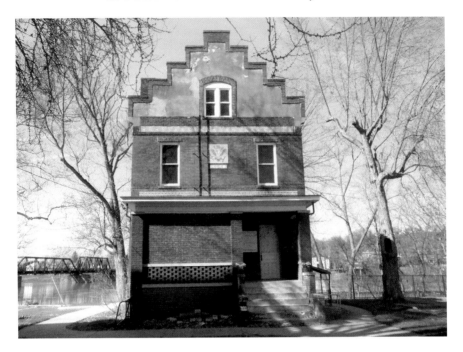

The Lockmaster's House. *Photo by Michael Pingrey.*

on call twenty-four hours a day. He lived in a house next to the lock that served as his home and office.

The Marietta Lockmaster's House was built in 1899 by the federal government. By that time, the Army Corps of Engineers was responsible for the lock system. This unusual building is larger and more elaborate than any other built along the Muskingum. Note the stepped gables, stained glass, decorative tile bands and American eagle adorning the front and back of the structure with Lock Number One below its talons.

The last lockmaster moved out in 1948, and the house fell into disrepair. Frequent basement flooding added to the building's problems. In 1969, the City of Marietta acquired the property. After serving as a community center for several years, it is now being renovated and transformed into the Marietta Cycling and Rowing Club's headquarters.

Downtown

U.S. Post Office

275 Front Street

Marietta's post office is so large and imposing that many visitors assume it is the county courthouse. Marietta's first post office opened in 1794, and over the years mail was handled in several locations. A few months after the current post office building opened in 1912, it was completely surrounded by the Muskingum River. It became an island during the 1913 flood. When the water finally receded, the post office's beautiful marble floors were caked with putrid mud.

Flood Marker

258 Front Street

There is another "Ivan Was Here" marker across the street from the Post Office at 258 Front Street. This location also has a large plaque that describes the flood of March 1964.

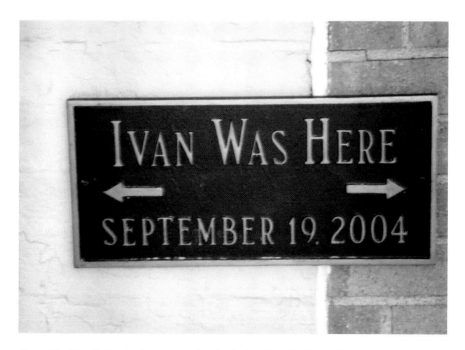

"Ivan Was Here" signs indicate water depths during the 2004 flood. Ivan was the storm that brought the destruction. *Photo by Michael Pingrey.*

The Corner of Front and Putnam Streets

The intersection of Front and Putnam Streets used to be the very heart of Marietta's downtown. Built in 1819, 100 Putnam may be the oldest commercial building in town. It has housed many different types of establishments, including shops, a school and a reading room. For more than ninety years, it was home to a succession of drugstores and even served as Marietta's post office. The brick and stone building on the opposite corner, 101 Putnam Street, was the site of the Bank of Marietta. It dates from 1833.

PUTNAM STREET

Putnam Street was mainly residential until the 1890s oil and gas boom, when the first block, in particular, became a desirable location for business and retail establishments. Soon, Putnam Street was lined with shops selling everything from sofas to ladies' unmentionables. Over the years, there were also bakers, barbers, grocers, two meat markets, a hat shop, a hardware store, a sign painter, plumbers, a billiard hall and several saloons. Of course, businesses came and went just as they do today, and by the middle of the twentieth century, national chains such as JCPenney and Montgomery Ward were part of the mix. Many area residents have fond memories of throngs of people Christmas shopping on Putnam Street.

Washington County Courthouse

205 Putnam Street

In Marietta's earliest days, court proceedings were held in the Campus Martius fort. The first separate, freestanding courthouse opened in 1799. It was located directly across Putnam Street from today's courthouse, where the ten-story Dime Bank building now stands. The first courthouse was a two-story log building with walls three feet thick. It included a courtroom, a jury room and a two-room living area for the jailer and his family. The jail, which was located in the rear of the building, was supposedly so well constructed that no prisoner ever escaped. The courthouse roof was topped with a cupola that contained a bell that chimed at 9:00 a.m., noon, 9:00 p.m. and each time a townsperson died.

Downtown

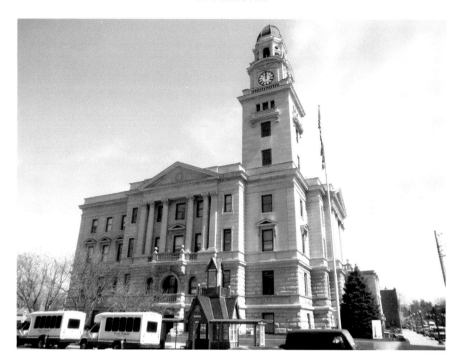

The Washington County Courthouse. *Photo by Michael Pingrey.*

Marietta's founders brought their New England notions of justice to the frontier. They erected stocks, pillories and whipping posts on the lot where today's courthouse stands. Stocks and pillories are restraint devices that clamp down around people's arms or legs. Those sentenced to sit in the stocks or stand in the pillory did so in full view of the entire town. The point was not to inflict pain, although the experience was far from comfortable; rather, it was to humiliate the person and to destroy his or her reputation. Some criminals' sentences did include physical punishment, which is what the whipping posts were for. Crowds gathered each time a public flogging took place.

In 1823, a larger courthouse, the second, was built on the punishment grounds, where the Washington County Courthouse is now. The jail continued operating in the original log building across the street until a new jail was built on the same spot in 1848. That arrangement worked until the late 1800s, when city and county officials decided it was time for another upgrade.

The next new courthouse, the third and the one that stands on the corner of Putnam and Second Streets today, was a source of great community pride. April 9, 1901, the day the cornerstone was laid, was a public holiday. Schools and businesses closed, people decorated their homes, and more

than one thousand wearing their finest spring outfits gathered to witness the birth of the new Temple of Justice. When construction was completed the following year, author Thomas J. Summers described the courthouse as "an ornament to the city" and "the most superb structure in Southeast Ohio."

Step inside. The Washington County Courthouse is open to the public during normal business hours. It contains a few quirky elements, not the least of which are the swastikas that decorate the tile floors. The swastika is an ancient symbol that appears worldwide. When the courthouse was new, the swastikas didn't bother the citizens of Washington County at all. In fact, they liked them. However, when the Nazis rose to power, the swastikas bedecking the floors began to have a jarring effect on people, especially those who entered the building unaware of its decorative theme.

After endlessly pointing out that the courthouse swastikas faced left, the opposite of the right-facing version adopted by Hitler, beleaguered officials tacked up a sign to illustrate the difference between a left-facing swastika, which they called an "Indian Motif," and a right-facing figure labeled a "German Swastika." The explanatory sign still hangs on a column near the main entrance.

The gold lions that flank the steps of the Second Street entrance came from a grand house that had to be torn down after the 1913 flood. Their names are Walter and Lawrence, although no one seems to know for sure which is which.

Theaterland

200 and 300 blocks of Putnam Street

The residents of Marietta had a surprisingly large number of entertainment choices in the late 1800s. Concerts, operettas, plays, lectures and magic

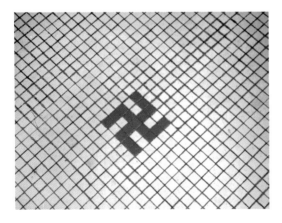

Swastikas adorn the Washington County Courthouse. *Photo by Lynne Sturtevant.*

lantern shows were presented by traveling theatrical troupes. Vaudeville acts with comics, magicians and animals were especially popular. Every summer, showboats steamed up and down the Ohio, delighting crowds at every stop. By the early years of the twentieth century, there were five live performance theaters in downtown Marietta. Two of the historic buildings still stand on Putnam Street.

MOVP Theater

227 Putnam Street

The Mid-Ohio Valley Players (MOVP) Theater was built in 1914 as a vaudeville house. Its original name was the Putnam Theater. The Putnam was converted into a movie theater in the 1920s, and its name was later changed to the Cinema. Since 1977, it has been home to Marietta's community theater group.

The Colony Theatre

222 Putnam Street

On the other side of Putnam Street stands the Colony Theatre, originally known as the Hippodrome. The first Hippodrome Theatre was a vaudeville house located on Second Street. The "Old Hipp," as its regular patrons fondly called it, was torn down in 1918, and a much larger version was built at 222 Putnam Street. The new theater, complete with all modern amenities, opened in 1919. It was both a live performance venue and a movie house. The first feature shown was the silent film *Daddy Long Legs*, starring America's Sweetheart Mary Pickford. Over the years, the Hippodrome changed with the times, converting to sound in 1929 and undergoing a series of renovations and other improvements. In 1949, its name was changed to the Colony. The theater's owners struggled with escalating costs, declining attendance and competition from newer, smaller theaters throughout the 1960s and '70s. It all finally became too much, and the Colony closed its doors in December 1985.

As you stand on Putnam facing the Colony's entrance, it doesn't look like much, but the building is larger than it appears. The Colony has twelve hundred seats, a double balcony, a huge stage, an orchestra pit, offices and seven basement dressing rooms, including one designed especially for chorus girls. And even though it is quiet and vacant at the moment, its future

looks bright. A few years ago, the Hippodrome/Colony Historical Theatre Association was formed. The group is working to restore the theater to its former glory. Renovations are underway, and soon excited theater- and moviegoers will fill the balconies of the majestic old building once again.

The Auditorium

301 Putnam Street

Marietta's most magnificent theater no longer exists. The Auditorium was a fifteen-hundred-seat live performance theater located on the top floor of the old city hall, which was built in 1893. The city hall also contained the mayor's office, various city departments and the city jail, not to be confused with the county jail down the street. In 1926, the Auditorium was converted to a movie theater. In 1935, a prisoner incarcerated for public intoxication set fire to the ceiling of his cell and burned the entire building to the ground. The new city hall, which is still in use today, opened in 1937 at the same location, 301 Putnam Street.

Lovely ladies on stage at the Auditorium. *Courtesy of the Washington County Historical Society.*

Downtown

The St. Clair Building

216 Putnam Street

Today, the St. Clair Building is a decrepit, spooky, empty building. But in its heyday, it was the talk of the town. Built in 1900 in what was known as the Metropolitan style, it was a state-of-the-art office building. It had a fast-running elevator and "sanitary plumbing" and was touted as a symbol of Marietta's progressiveness.

The Unitarian Church

232 Third Street

Construction of the brick church on the corner of Third and Putnam Streets was begun in 1855 and completed two years later. The entire project was financed by Nahum Ward, a wealthy land speculator and lifelong Unitarian who had served as Marietta's mayor. The architect was John Slocomb, who also designed St. Luke's Episcopal Church at 320 Second Street and three local mansions: the Anchorage, the Castle and Henderson Hall, each of which is described elsewhere in this book.

 The Unitarian church has a number of interesting features, not the least of which are its bricks. Nahum Ward was interested in mysticism, spirituality and history, and he wanted to link his church to Marietta's distant past. More than two thousand years before Ward's time, ancient Mound Builders constructed a massive sacred complex on the site that became downtown Marietta. The Hopewell and their predecessors, the Adena, are discussed in detail in chapter four. The most enigmatic feature of the ancient earthworks was a 150-foot-wide, 680-foot-long walled passageway that ran from the banks of the Muskingum River to an elevated square near present-day Third Street. In Nahum Ward's time, the walls were purchased and leveled by a local businessman, who turned the clay they contained into bricks. Ward purchased the bricks, and John Slocomb incorporated them into the walls of his church.

 As construction was coming to a close, a laborer noticed a gap on the Third Street side of the church's tower. A brick was missing. The man was paid fifty cents to climb eighty-five feet up the tower and insert a single white brick in the gap. The lone white brick is still visible. Even though the Unitarian church is several blocks from either river, the building has suffered

flood damage. Rising water in 1884 destroyed the church's pipe organ. In the catastrophic 1913 flood, the basement filled completely, and three feet of water sloshed into the sanctuary.

Step inside. The woodwork, wainscoting and pews are original, as is the elegant curving staircase that leads to the balcony. According to a local legend, the master craftsman who carved the staircase was a slave. Even though slavery was never legal in Ohio, sometimes slaves from Virginia were brought across the river to work. When the slave's owner saw the beautiful staircase, he freed the man on the spot.

Christ Weeping over Jerusalem, the large painting on the wall behind the pulpit, is also steeped in legend. It was painted by local portrait artist Sala Bosworth and is a copy of a work by the English artist Charles Eastlake. When Bosworth unveiled the painting, people were shocked by the uncanny resemblance the painted image of Simon Peter bore to Nahum Ward, which pleased Ward to no end. Hardly a shrinking violet, he expected to get credit for his works. He liked the idea that his face would permanently gaze at the congregation. But he wanted to make sure non-churchgoers knew who was responsible for the building too. So he purchased a block of stone and hired a mason to carve his name upon it in huge letters. He then had the stone attached to the church's exterior. Stand across Putnam Street in front of city hall and look at the base of the church tower. You can't miss it. While you're looking up, notice the stone spires topped with decorative finials. "Slocomb spires" are also part of the design of St. Luke's Episcopalian Church and the Castle, which is covered in chapter four.

St. Luke's Episcopal Church

320 Second Street

For those interested in the work of Marietta architect John Slocomb, a slight detour—less than one block—is highly recommended. Take Putnam to Second Street. Turn north on Second. You will walk along the side of the courthouse past Walter and Lawrence, the gold lions. Keep going until you reach 320 Second Street, St. Luke's Episcopal Church. This lovely Gothic building was completed in 1856. Its design and several of its decorative elements are similar to those of the Unitarian church. Many find the smaller St. Luke's the more elegant of the two.

Downtown

Second Street to Butler Street

Return to Putnam, cross the street and continue walking down Second Street. The very quiet block you have just entered used to be the noisiest part of downtown. For much of the nineteenth century, Marietta was a railroad center. The large parking lot on Second Street known as the Parking Partners Lot was where the train depots and freight yards were. There were two passenger stations. The grandest and busiest was the Union Depot, which was located in the Putnam Street end of today's parking lot. The Union Depot was either a Victorian monstrosity or a masterpiece of late nineteenth-century design, depending on your point of view. It had towers, spires, dormers, a steeply pitched red tile roof and interesting angles. The top floor housed a full-service restaurant and sleeping rooms. A train shed was attached to the back so that passengers could board and detrain without being subjected to the elements. During the Union Depot's heyday, twenty-one passenger trains arrived and departed each day. Fire severely damaged the Union Depot in 1910. The structure was demolished in the 1940s. The much smaller Penn Station was also on Second Street, down the block close to Butler Street. Ticket and freight agents operated out of offices all over downtown.

Before the railroad arrived, Butler Street and the Parking Partners Lot were low-lying, marshy areas that were often filled with standing water.

Even though this postcard is titled "Union Station," it is a drawing of the smaller Penn Station. *Courtesy of the Washington County Historical Society.*

The railroads raised the ground level with ten to fifteen feet of fill. This allowed them to build the stations and freight yard, as well as the tracks that connected the Second Street complex with the railroad bridge across the Muskingum River, today's pedestrian bridge to Harmar. Several interesting photos of the neighborhood during railroad days are displayed on the ground floor of the Wesbanco branch at the corner of Second and Butler Streets. Visitors are welcome.

The Galley Restaurant and the Adelphia

203 Second Street

For most of its life, the building that now houses the Galley Restaurant was the Hackett Hotel. Directly across from the railroad yards, the Hackett was busy night and day. It was known for its convenient bar and the contingent of prostitutes who lived on the premises. By the time the Hackett closed in the mid-1960s, the building was in terrible shape. In the 1980s, a new owner renovated the building and transformed it into a restaurant. He wanted to preserve as much of the building's turn-of-the century character as possible.

Step inside. In addition to retaining the metal wainscoting, tin ceilings and wood floors, the architect added a unique decorative element. Several antique doors, all of which came from the Hackett Hotel's bedrooms, hang on the back wall of the dining room. Take a look at the Adelphia Music Hall next door. The Adelphia's entrance is through the Galley. The Adelphia also celebrates the atmosphere and architecture of turn-of-the-century Marietta. When you leave the Galley, pause in the Tiber Way parking lot and look at the building's exterior wall above the patio awning. You'll see ghost ads for the old Hackett Hotel's cocktail lounge. For information on the Galley and the Adelphia, visit www.thegalleymarietta.com or call 740-374-8278.

Tiber Way

A small stream runs through the heart of downtown and empties into the Muskingum River near the old railroad bridge. Scouts and settlers who were in the area prior to Marietta's founding called it Goose Creek. When Rufus Putnam and the Ohio Company arrived, they renamed it the Tiber after the famous river that flows through Rome.

Downtown

Regardless of what it's called, the creek has always caused problems. When the Muskingum River rises, it backs up. Today, that means water in downtown basements and flooded parking lots and tennis courts at Marietta College. In the past, it was more than a source of high water; the creek was a health hazard. It was particularly awful during the summer, when it reeked of raw sewage and the swampy area around it became a vast mosquito breeding ground.

In 1900, an enterprising businessman named Colonel Riley decided to tackle the Goose Creek problem. After he routed the creek into a nine-foot-wide sewer pipe, he dumped several feet of fill on top. He then built a snazzy three-story building over the subdued and submerged creek. In a nod to Marietta's founders, Colonel Riley named the building Tiber Way. The building, which still stands on the north side of Butler between Front and Second Streets, is curved so that trains could make their way around it as they traveled between the railroad yards and the Muskingum River Bridge.

Tiber Way made Marietta's community leaders very happy. The building was not only a splendid addition to downtown, but also, thanks to Colonel Riley, the stench of raw sewage and the swarms of bloodthirsty mosquitoes were fading memories. Butler between Front and Second Streets had been transformed from useless marshland to one of the most desirable locations in town. Tiber Way included commercial and residential units, as it does today. Colonel Riley moved into a luxurious three-story townhouse on the Second Street end of the building. The Marietta Sanitarium, a twenty-six-room hospital, opened on the opposite end. Doudna Funeral and Undertaking Services, Colonel Riley's second business tenant, moved into the space next to the hospital.

Businesses opened and closed, people moved in and out and it wasn't long before everyone forgot about the creek flowing through the sewer pipe beneath the building—until September 2004, when the remains of Hurricane Ivan arrived. Goose Creek's enclosing culvert was compromised, and a large segment of Tiber Way's ground floor caved in. The sinkhole extended from the building's interior to the center of the parking lot on Butler. When workers excavated the surrounding area in an effort to stabilize the hole, they found the remains of a wooden footbridge that crossed Goose Creek in the 1700s.

Muskingum Park

Front Street along the Muskingum Riverbank from Putnam to Wooster

Muskingum Park is a peaceful green area with large shade trees, a bike path and benches where you can sit and watch the sun sparkle off the surface of the river. This stretch of ground has been a public park since Marietta's earliest days, when Rufus Putnam designated it a "commons." Before that, the ancient Adena and Hopewell people built semipermanent campsites here. During more recent times, the first governor of the Northwest Territory was inaugurated in the park; three U.S. presidents visited; several obelisks, monuments and a pavilion were added; and a sculpture by a famous American artist was installed. As if that weren't enough, this innocuous strip of grass became the center of a heated controversy when it was chosen as the setting for a doomed national shrine.

Two chunky sandstone obelisks topped by carved eagles stand on either side of Front Street near Putnam, where the park begins. Another set of eagle-topped obelisks stands farther down Front near Wooster Street at the park's other end. Each bears three horizontal stars, as well as an inscription relating to the formation of the Northwest Territory, Marietta's founding or the beginning of the westward expansion of the United States.

The obelisks, the stone landing and stairs on the riverbank and a group of figures sculpted by Gutzon Borglum, the artist who carved Mount Rushmore, were erected in 1938 to mark Marietta's sesquicentennial, or 150th anniversary. These elements were designed to be part of a national park commemorating Marietta's role in the country's westward expansion. Plans called for a large auditorium and a museum. The entire complex was to be maintained by the federal government under the auspices of the National Park Service. President Franklin Roosevelt lobbied Congress on Marietta's behalf and obtained approval for the project. There was one hurdle. The City of Marietta needed to provide matching funds, 50 percent of the total, in order for construction to move forward. As city leaders hemmed, hawed and argued, Borglum and others began work on the statues, obelisks and the riverbank landing. In the end, Marietta did not allocate the necessary funds. The elements already completed were installed; President Roosevelt came to the park, unveiled Borglum's statue grouping and made a speech; the rest of the project was cancelled; and the stories, rumors and urban legends began to swirl.

Downtown

The Way West Monument, Muskingum Park. This statue grouping has several alternate names. *Photo by Michael Pingrey.*

The most misunderstood monument in Muskingum Park is Borglum's lovely, somewhat weathered work of art. Local people cannot even agree on the statue grouping's official name. Candidates include the Start Westward Memorial, the Memorial to the Start Westward of the Nation, A Nation Moving Westward, the Start Westward Movement, the Start Westward of the Nation, the Start Westward of the United States, the Way West Monument and the Westward Ho Memorial.

The sculpture includes three men in colonial garb standing in front of a small boat that contains a woman and two male passengers. The controversy and confusion arises over the statue's position and orientation and what stage of the westward journey it portrays. Some think it captures the moment just before the pioneers left New England to begin their trek west. According to this interpretation, two of the main figures are looking toward the new lands, while the other glances back over his shoulder to the life they are leaving behind. The problem is that none of the figures are facing west. The men supposedly looking toward the future are facing north, and the one looking back is gazing wistfully toward the southwest. Proponents of this theory

have an explanation. The figures are not facing the proper directions—the directions Borglum intended—because Mariettans demanded that the grouping be rotated from its planned position. They wanted it placed so that they could see the statues' faces as they drove up and down Front Street.

There is another point of view. Supporters of this position think the suggestion that the statue was rotated is nonsense. They believe the grouping is situated exactly as the artist intended. The figures do not represent the beginning of the journey; rather, the sculpture portrays the pioneers' arrival here. The three men have just climbed the bank of the Muskingum and are therefore facing the appropriate directions. Stand in front of the grouping and take a good look. What do you think?

The controversy does not end there. Every now and then, rumors that the figures have been secretly altered bubble through town. Many swear none of the statues has its original nose. Some think all of the heads have been replaced, although it is not clear when the switch was made or who was behind it. The biggest points of contention, however, revolve around the sculpture's condition and what should be done to maintain it. People worry the stone is eroding, that the details become softer and fainter with each heavy rain. Some want to build a roof over it. A few think the only responsible option is to enclose it in a climate-controlled building. The situation is further complicated by the fact that it is not clear who is responsible for the monument's maintenance. The federal government isn't. It walked away when Marietta failed to come up with the matching funds in 1938. Although many local people think the Ohio Historical Society is in charge, people in Columbus do not share their opinion. The discussions—and the rain—continue.

In 1988, to mark Marietta's bicentennial, the local Kiwanis Club stepped forward and sponsored improvements to the monument, which it calls the Memorial to the Start Westward. The American flag and the flags of the six states formed from the Northwest Territory—Ohio, Indiana, Illinois, Michigan, Wisconsin and Minnesota—were added, and permanent lighting was installed.

As you stand facing the Muskingum River, with your back to the sculpture group, you will notice a stone monument near the bike trail. It commemorates Arthur St. Clair's inauguration as the first governor of the Northwest Territory in July 1788. The stone stairs and railings directly before you on the riverbank were part of the 1938 installations.

The park contains other monuments and points of interest not connected to the sesquicentennial fiasco. Washington County's Civil War Soldiers Monument stands near the parking lot at the corner of Front and Putnam

Downtown

The Civil War Soldiers Monument, Muskingum Park. *Photo by Michael Pingrey.*

Streets. The memorial, which is surrounded by a small iron fence, includes the statue of a Union soldier atop a tall, narrow obelisk carved with the names of significant battles: Shiloh, Corinth, Antietam, Mission Ridge and Gettysburg. Note the inscription on the obelisk's base. The conflict we call the Civil War is referred to as "the War for the Suppression of the Rebellion of 1861." The cannons mounted at each corner are called Parrott guns. They are from the Civil War era. The monument was erected in 1875.

The gazebo near Scammel Street is known as the Bicentennial Pavilion. Added in 1988, it is a popular spot for weddings, concerts and public gatherings of various sorts. The final monument as you head north toward Wooster Street is a memorial to the four thousand Washington County residents who served in World War I, World War II, Korea and Vietnam.

After strong storms damaged or destroyed hundreds of trees around town in June 1998, David Ferguson used his chainsaw to transform several of the splintered trunks into works of art. The totem pole–like sculpture near the

Front Street sidewalk beyond the Bicentennial Pavilion is called the "Critter Tree." It honors the animals that live in Muskingum Park and features an owl, a raccoon, a squirrel, a rabbit, a chipmunk and a turtle.

Several historic buildings lie on the other side of Front Street, across from Muskingum Park.

Masonic Temple

308 Front Street

The organization of American Union Lodge Number 1, F&AM, precedes the Revolutionary War. After a hiatus during the fighting and several delays and complications, the lodge was reestablished in Marietta in 1790. It is the first Masonic lodge chartered under American authority. It is also the oldest institution in Marietta. Benjamin Franklin suggested the design of the lodge's seal, which was engraved by Paul Revere. The Masonic Temple building on Front Street opened in 1907. Prior to that time, meetings were held in several locations around town.

First Congregational Church

318 Front Street

During Marietta's earliest days, religious services were held in the safety of Campus Martius. The Northwest Territory's oldest church, the First Congregational Church, was chartered in 1796. It had thirty-one members. In 1809, a twin-towered frame church building was dedicated on this site. Muskingum River pilots and captains who used the structure as a navigation aide called it the Two-Horned Church. After the church burned in 1905, a new brick building with a very similar design—the church you see today—rose on the same site. Marietta's First Congregational Church is the oldest church in continuous operation west of the Allegheny Mountains.

Meigs House

326 Front Street

This lovely Federal-style house was built in 1802 for Return Jonathan Meigs Jr., who held a number of important public offices. He served as a

prosecuting attorney and as a Northwest Territory judge. He was Ohio's first postmaster, the fourth governor of the state, an Ohio Supreme Court justice, a United States senator and postmaster general of the United States. Meigs County is named after him.

The Meigs family's use of the name Return dates to the early 1700s. According to family lore, Janna Meigs, the great-grandfather of Return Jonathan Meigs Jr., repeatedly asked a fetching young lady named Hannah Willard to marry him. But each time he asked, she refused. Before giving up entirely, Janna Meigs decided to propose to Hannah one last time. She said no, and he informed her that he would never darken her door again. As he turned to leave, a sobbing Hannah said, "Return and I will marry you." The couple named one of their sons Return to commemorate the dramatic moment. No one knows if this account is true, but the story has been passed down through generations of Meigs descendants.

The Buckley House

332 Front Street

This frame house was built in 1879. It is named for the wealthy oil producer who lived in it for more than fifty years. It is notable for its two-tiered porch and views of Muskingum Park and the river beyond. Today, it is a restaurant. For information and reservations, visit www.bhrestaurant.com or call 740-374-4400.

The Shipman and Holden Houses, Cawley and Peoples Funeral Home and Peoples Mortuary Museum

404 and 408 Front Street

Now a single building, the Greek Revival houses at 404 and 408 Front Street used to be two separate structures. The Shipman House at 404 Front Street, to your right as you face the building, was built in 1834 for the pastor of the First Congregational Church less than a block away. The Holden House at 408 Front Street was built in 1853. The Shipman and Holden Houses are listed on the National Register of Historic Places. Cawley and Peoples Funeral Home owns both buildings.

Step inside. The public is welcome to visit the ground floor of the Shipman House, which is a gift shop.

Peoples Mortuary Museum, located behind 408 Front Street, contains a fascinating and tastefully displayed collection of funeral memorabilia. For many, though, the museum's main draw is its vintage vehicles, all of which are in perfect condition. See an 1895 horse-drawn hearse, gleaming Packards and a 1927 Henney that was recently used in a Hollywood film. Tours of the museum are complimentary, but reservations are required. Please call ahead, and remember that due to the nature of Cawley and Peoples' business, schedules are subject to change. If you're not sure if the Mortuary Museum is right for you, visit www.cawleyandpeoples.com and click on the museum page. You'll find several pictures that will give a feel for the museum experience.

3
Harmar

The West Side

Marietta's west side, the part of town across the Muskingum River from downtown, is known as Harmar (rhymes with farmer). Harmar's founding predates Marietta's by three years.

Fort Harmar

In 1785 the Continental army, as the U.S. Army was known at that time, sent a contingent of troops to the confluence of the Muskingum and Ohio Rivers. The men built a pentagon-shaped fort on the Muskingum's western bank. The installation was named after its first commanding officer, General Josiah Harmar. The one hundred men stationed at Fort Harmar were charged with the nearly impossible task of keeping an ever-growing population of unruly white squatters from building on Indian lands in violation of several treaties.

In the spring of 1788, the soldiers were advised to be on the lookout for Rufus Putnam and his associates, who were sailing down the Ohio River toward Fort Harmar. They planned to make a grand landing at the mouth of the Muskingum in early April. On April 7, right on schedule, the flotilla appeared. Fort Harmar sentries sounded the alarm and then watched in disbelief as the boats sailed past the mouth of the Muskingum and kept heading downstream.

It took several hours for the Ohio Company to get all of its boats slowed down and pulled in to shore. Troops from the fort helped tow them back up the swiftly flowing Ohio. When they had all arrived safely at the Muskingum's

mouth, the soldiers stood back and watched respectfully as Putnam and the men of the Ohio Company scrambled up the slippery riverbank and officially founded Marietta.

Divorce and Reconciliation

Although part of the same frontier community, from the earliest days there was friction among those who lived on the east and west sides. In 1837, the low-level mistrust and suspicion exploded into open warfare. The dispute, which centered on the location of a planned Muskingum River boat lock, became so toxic that westsiders voted to secede from Marietta. They established a separate town and named it Harmar.

It took more than fifty years for everyone to calm down enough to rationally discuss the matter. Sensing that the time was right—the discovery of oil and gas was fueling an economic boom, and even the diehards seemed to be in a conciliatory mood—the Marietta Board of Trade invited Harmar to formally rejoin Marietta. An official measure was drawn up, and west side residents went to the polls in 1890. The measure passed, but just barely. It carried by only ninety votes.

Today, the Putnam Street Bridge and the Harmar Railroad Bridge connect the east and west sides forming the largest historic district in Ohio. Cross the river and you'll find some of the area's oldest houses, two unusual museums, shops and restaurants. Harmar is not overly commercialized. It is essentially a residential area. Those who live in the neighborhood still have an independent streak. They will quickly point out that no matter what the people in Marietta say, Harmar is where the town's history really begins.

Exploring Harmar

The Harmar Railroad Bridge, also known as the Harmar Pedestrian Bridge

The bridge began life in 1856 as a covered bridge for pedestrians and horse-drawn wagons. In 1873, the superstructure was reinforced, and the span was converted into a railroad bridge. Repeatedly rebuilt and repaired after devastating floods, it carried train traffic until its closure in 1968. In 1987, thanks to the efforts of the Historic Harmar Bridge Company, it reopened as a pedestrian walkway. The Harmar Railroad Bridge is one of the last

Harmar

The historic Harmar Railroad Bridge. *Photo by Michael Pingrey.*

operational hand-cranked, swing-span railroad bridges in existence. It is cranked open each summer during the Historic Harmar Days celebration, which usually occurs in late July. Check with the Marietta–Washington County Convention and Visitors Bureau for exact dates and more information.

The Putnam Street Bridge

If you prefer to drive between downtown Marietta and Harmar, use the Putnam Street Bridge, which is also open to pedestrians. It has wide, safe sidewalks. If you walk, take a moment to read the plaques mounted along the way. They describe Marietta's river history.

Vintage Railroad Cars

The vintage railroad cars near the Harmar entrance to the Railroad Bridge and the old train tracks commemorate Marietta's days as a railroad town, an era described in chapter one. Various shops and other small businesses,

including a dog grooming salon, have called the rail cars home over the years. Please feel free to look around.

Modern Trains

A regularly scheduled train still passes through Harmar twice a day. It carries coal to the Beverly power plant about twenty-five miles north of town. The train travels on the tracks that run down the middle of Harmar Street. Depending on what time of day you visit Harmar, you may be lucky enough to hear the train's whistle as it clatters through town.

FORT STREET

Fort Street is the lane that runs along the Muskingum riverbank. Some of the oldest houses in Marietta are located on this quiet street. Almost all the buildings face the river. A large portion of Fort Street is pedestrian. Park elsewhere and walk.

Levi Barber House

407 Fort Street

The Levi Barber House was built in 1829. Levi Barber was a member of the U.S. Congress. This house has always been occupied by members of the Barber family. It is a private residence.

Ohio's First Bank—David Putnam House

519 Fort Street

One of the oldest homes in the area, the Putnam House was completed in 1805. Ohio's first bank was chartered in 1808. This building housed the bank and the Putnam family at the same time. David Putnam was the head of the household, the bank's director and the cashier. Members of the family lived in the house until the 1930s. In 1934, the house served briefly as the "Marietta Home of Today," a showcase for the latest electrical gadgets, appliances and other household innovations. It is now a private office.

Harmar

Douglas Pattin House

521 Fort Street

This elegant stone house built in 1899 is now a private office.

MAPLE STREET

The first block of Maple Street, from the Muskingum riverbank to Gilman Avenue, is the heart of Historic Harmar Village. At one time a rough neighborhood of tenements and taverns, Maple Street has evolved and mellowed. Shops offering vintage goods and antiques line both sides of the brick street. Shopkeepers spend warm afternoons relaxing on the benches outside their businesses. The pace is slow, the tone is gracious and there's always time for conversation.

The Marietta Soda Pop Museum

109 Maple Street

The soda museum's extensive collection of soft drink–related paraphernalia must be seen to be believed. There are shot glasses, magnets, trays, T-shirts, calendars, Christmas ornaments, thermometers, bottle openers, coffee mugs and more. Most of it is Coca-Cola nostalgia. A few strategically placed antique gasoline pumps break up the sea of red and white. You can take it all in from a stool at the museum's 1950s lunch counter, where you can order light snacks, hand-dipped ice cream, old-fashioned ice cream sodas, sundaes, milkshakes and, of course, Coke. The owner, Peewee, will gladly tell you about any item in the museum that captures your fancy. It's all for sale. The Soda Pop Museum's hours change frequently. Call in advance, 740-376-COKE (2653), or visit www.mariettasodamuseum.com.

The Harmar Tavern

205 Maple Street

The folks at the Harmar Tavern must be doing something right. They've been in business since 1900. The Harmar Tavern is the self-proclaimed

home of the "Sure to be Famous Fried Bologna Sandwich." If fried bologna isn't your thing, they also serve burgers, fries and other pub grub. There's a shady outdoor beer garden for warm afternoons. The Harmar Tavern serves breakfast on Sunday. Call 740-373-8728 for more information.

Gilman Avenue

The Busy Bee Restaurant

226 Gilman Avenue

The Busy Bee is a Harmar landmark. Opened in the 1950s, the Busy Bee's style and décor are original. Open for breakfast, lunch and early dinner, the Busy Bee does not serve alcohol. There is free parking in the lot next to the restaurant. Call 740-373-0486 for hours and daily specials. It is closed on Sundays.

Spagna's Restaurant

301 Gilman Avenue

Spagna's is a traditional Italian restaurant with good food, great atmosphere and an outdoor patio for warm weather dining. It occupies the ground floor of one of the west side's oldest and largest buildings. Built in 1848 as the Odd Fellows Hall, it has housed a grocery store, a meat market and several other firms, including a barbershop. Look closely at Spagna's entrance. It's flanked by two old wooden barber poles. The main dining room features a long, highly polished bar, custom made for the restaurant from 125-year-old doors, and a glorious back bar unit that began life in another Marietta establishment many years ago. The unit was sold and taken to northern Ohio and then to Clarksburg, West Virginia, where the current owner located it. After many visits, phone calls and a little pleading, he managed to buy the bar unit and bring it back home. Spagna's is very popular, especially during warm weather. Reservations are highly recommended; call 740-376-9245. It has a full bar and is closed on Sundays.

Harmar

The Harmar Post Office

Gilman Avenue at the Railroad Crossing

The Harmar Post Office symbolized the west side's independence during the years that Harmar and Marietta were separate towns, from 1837 to 1890. The little frame post office building was originally located on Maple Street near where the Harmar Tavern now stands. Lydia Young served as Harmar postmistress from 1864 to 1885. Unfortunately, the post office is not open to visitors, but feel free to step onto the porch and look in the windows.

The Children's Toy and Doll Museum

206 Gilman Avenue

Antique dolls and dollhouses, circus memorabilia, vintage toys and miniatures are displayed in a restored Victorian home. Each room of the house, which was built in 1899, has a different theme. The Children's Toy and Doll Museum is open May through October, Saturdays and Sundays, from 1:00 p.m. to 4:00 p.m. The museum staff will gladly open at other times by appointment; call 740-373-0799 or visit www.toyanddollmusuem.com.

The Henry Fearing House

113 Gilman Avenue, Corner of Gilman and Market

The Fearing House dates from 1847. The Washington County Historical Society, which owns the property, has restored it so that it "exemplifies the

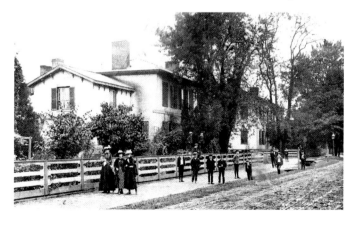

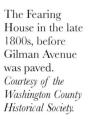

The Fearing House in the late 1800s, before Gilman Avenue was paved. *Courtesy of the Washington County Historical Society.*

lifestyles of middle-class Marietta during the Victorian era." The Henry Fearing House is open from May to October, Fridays and Saturdays, from 1:00 p.m. to 4:00 p.m. Private tours may also be arranged by calling 740-373-3226. There is no admission charge, but donations are always welcome.

The French Monument and the Site of the Knox Boatyard

Corner of Gilman Avenue and Virginia Street, Overlooking the Ohio

The stone monument on the riverbank commemorates the early French presence and influence in the Ohio Valley. For decades prior to Marietta's founding, French fur trappers operated throughout the region. Each time a trapper entered new territory, he buried an engraved lead plate that claimed the land for the king of France. In 1798, two boys playing on the riverbank near where the monument now stands unearthed a French lead plate dated 1749. By the time anyone recognized its significance, most of the plate had been cut into pieces, melted down and turned into bullets. What remains is on display in the American Antiquarian Society facility in Worcester, Massachusetts.

The monument's plaque, which is inscribed in French, was a gift from the government of France on the occasion of Marietta's sesquicentennial, or 150th birthday, in 1938. It is not the first gift from the French government. It is, however, the first to actually arrive. Shortly after Marietta's founding, Marie Antoinette had a special bell made to thank the people of Marietta for naming their town after her. Sadly, the ship and the bell were lost at sea.

The sidewalk and low wall around the French Monument create a pleasant viewing area on the Ohio riverbank. If you look down at the water to your right, you'll notice that paving stones cover the bank. The stones are all that remains of the Knox and Sons Boatyard. Knox and Sons, a steamboat manufacturer, was a major employer during Marietta's second round as a boatbuilding center from the mid-1800s to the early 1900s. The first round of boatbuilding, which occurred in the early 1800s, focused on oceangoing vessels. See chapter one for more about Marietta boatbuilding.

Other Harmar Sights

The Site of Fort Harmar

Fort Square, Corner of Fort and Market Streets

Although nothing remains of Fort Harmar, the site is worth visiting for the remarkable views of the confluence of the Ohio and Muskingum Rivers. The fort sat approximately where Harmar Elementary school is today.

Open Door Baptist Church

301 Franklin Street

The structure at 301 Franklin Street is the oldest church building in Marietta. It was constructed in 1847 for the Harmar Congregational Church.

The Anchorage

403 Harmar Street

The Anchorage, the vaguely sinister-looking sandstone mansion looming on the hillside behind the Harmar Place Rehabilitation and Extended Care Facility, was Marietta's finest private home in its day. The twenty-two-room Italianate villa was designed by John Slocomb, the architect of the Castle and Henderson Hall. The house was built for Douglas and Eliza Putnam. According to local legend, after Eliza saw a New Jersey friend's enormous estate, she informed her husband that she wanted one just like it—or better—built in Marietta. Luckily, Douglas was the wealthiest man in town. Construction began in 1855 and was completed four years later at a cost of $60,000, approximately $2,000,000 in today's dollars.

Poor Eliza did not enjoy her dream house long. She died in her beautiful bedroom less than two years after moving into the mansion. The Anchorage passed through a series of owners. In the 1960s, it became a nursing and rest home. After the nursing home moved out in the 1980s, the building—complete with wet basement and leaking roof—was empty for more than a decade. In 1996, the Washington County Historical Society acquired the house. The society is slowly renovating it with the goal of restoring it to its former glory.

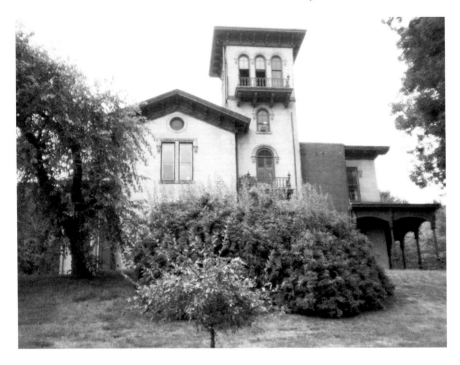

The Anchorage. *Photo by Michael Pingrey.*

Many Harmar residents believe Eliza Putnam's restless spirit still walks the halls of the Anchorage. There are also legends of tunnels, secret rooms and a connection to the Underground Railroad. David Putnam, Marietta's most famous and outspoken abolitionist, was Eliza's brother-in-law. His small, modest frame dwelling was next door to the Anchorage. David's house, an emergency station on the Underground Railroad, was demolished in the 1950s. A historic marker near the Anchorage's side porch notes his role in the area's history.

The Anchorage is open from time to time for special tours and events. Feel free to walk around the exterior. Contact the Washington County Historical Society for information; visit www.wchs-ohio.org or call 740-373-1788.

Harmar Cemetery

130 Wood Street

Established in 1796, Harmar Cemetery is Marietta's oldest graveyard. Many prominent citizens were buried here in the early years. However, the cemetery

was abandoned due to repeated problems with wet ground and flooding. Many of those laid to rest in Harmar Cemetery have been disinterred and reburied elsewhere. Douglas Putnam Sr. and fourteen members of his family were removed and reinterred in Oak Grove Cemetery in October 1904. Harmar Cemetery is open to the public. Take Gilman Avenue North to Wood Street. Turn left. The cemetery will be on your right. Be aware that the ground is often soggy.

Rinky Dinks Flea Market

404 Fort Harmar Drive

The largest flea market in the area, Rinky Dinks is a conglomeration of vendors selling everything from tires to chili dogs, from plastic cemetery decorations to used paperbacks. It's all housed in the former Rinks Bargain City Discount Department Store, hence the name.

Approach with caution. Some think Rinky Dinks is kooky and fun. Hardcore bargain hunters love it. Other people describe it as borderline bizarre and are put off by the atmosphere. As I write this, a large sign that says, "Stop All Foreign Aid" flutters from the front of the building. Rinky Dinks is open every Friday, Saturday and Sunday from 9:00 a.m. to 5:00 p.m.; cash only. For more information, call 740-373-4797.

You cannot reach Rinky Dinks on foot. You must drive. From the Marietta side of the Muskingum, take the Washington Street Bridge and follow Route 7 South. This section of Route 7 is called Fort Harmar Drive. After you go around a big curve, you will pass the Pearl Street Extension on your right. Rinky Dinks is next. There is a right-turn-only lane into the parking lot. Take it slow. There are so many potholes in the Rinky Dinks lot that you'll feel like you're driving on the surface of the moon. Rinky Dinks's address is 404 Fort Harmar Drive.

Bellevue Street

Running along the top of the ridge known as Harmar Hill, the appropriately named Bellevue Street has the best views in town. You cannot reach Bellevue Street on foot; you must drive. From the Marietta side of the Muskingum, take the Washington Street Bridge and follow Route 7 South to Lancaster Street, which is also the junction of Route 676. Turn right onto Lancaster

and follow it up the steep hillside. You will pass Bellevue, but you cannot turn in. Continue to the top of the hill and around the curve. You will see two signs. One says Lookout Point; the other says Lookout Park. Follow the sign to Lookout Point by turning left on Bartlett Street. Two blocks later, Bartlett ends at Bellevue Street and Lookout Point.

Lookout Point

Bellevue Street

The view from Lookout Point includes downtown Marietta, the Muskingum and Ohio Rivers and the rolling Ohio and West Virginia countryside. The column of steam and the smokestacks you see on the horizon are part of the Willow Island Power Plant. There are benches. Bring your camera—it's fantastic!

The House on Harmar Hill

300 Bellevue Street

Continue down Bellevue. The glorious yellow Queen Anne mansion at 300 Bellevue Street is one of the finest Victorian-era houses in town. Built to impress in 1901, its original owner insisted on the best location with the most beautiful view. Now a bed-and-breakfast, the House on Harmar Hill has a loyal repeat clientele. Some return just to sit on the house's wraparound porch. Call 740-374-5451 or 866-374-5451 for reservations and information.

You can leave the ridge by taking Douglas Avenue, the steep road that veers off to the left and down the hill in front of the House on Harmar Hill. Douglas Avenue joins Route 7 at the bottom of the hill. You can also retrace your path and return via Lancaster Street. To do so, turn right on High Street and continue to Alta Street. Turn right again. Alta becomes Lancaster. Follow it down the hill and back to Route 7.

4
The Downtown Residential District

Mansions, Mounds and Marietta College

The downtown residential district that includes Third, Fourth and Fifth Streets, and the intersecting streets, is one of the most delightful places in town. Brick streets, enormous trees, lovely yards, ancient Indian mounds, a historic cemetery, Victorian mansions and one of America's oldest continuously operating private colleges—it's hard to imagine a better place for an afternoon walk or leisurely drive.

As you explore this part of town, you will find that elements from the various periods of Marietta's past coexist. Our public library sits atop an ancient platform mound; homes built at the end of the nineteenth century overlook the graves of Revolutionary War veterans; and on campus, a state-of-the-art library sits in the shadow of a clock tower erected before the Civil War. It's a neighborhood like no other.

Marietta College—Education in the Wilderness

Marietta College's compact campus occupies approximately ninety acres in the center of town. It's bounded roughly by Greene, Seventh, Fourth and Putnam Streets. Feel free to walk through the pleasant grounds.

During the early 1800s, a number of small, private schools opened around town. Most had financial difficulties and failed. A few, however, were quite successful. Marietta College, chartered in 1835, evolved from

the Muskingum Academy. From the beginning, the course of instruction emphasized the liberal arts and was patterned after New England institutions such as Amherst and Yale. The members of Marietta College's first graduating class received their diplomas in 1838. In 1860, Marietta was awarded a Phi Beta Kappa chapter, the sixteenth college so honored. Women were admitted in 1897.

Today, Marietta College is a thriving institution nationally recognized for its academic standards and high levels of student satisfaction. A private school, it offers both undergraduate and graduate degrees. Marietta College is known for its Petroleum Engineering and China programs and for its NCAA Division III championship baseball team. Approximately fifteen hundred full-time students attend Marietta College.

There are four interesting buildings to see on campus: two new and two old. Start at the corner of Fourth and Butler at the planetarium, walk onto the mall and make your way toward the college president's house on Putnam Street. The pedestrian mall that bisects campus used to be the 200 block of Fifth Street.

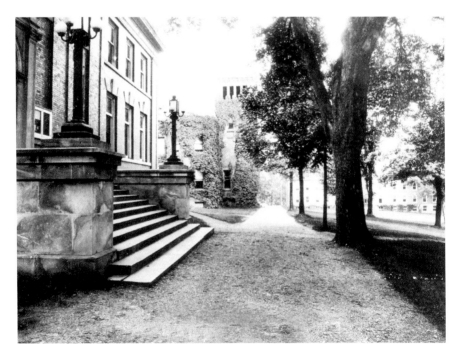

Marietta College in the middle of the twentieth century. *Courtesy of the Washington County Historical Society.*

The Downtown Residential District

The Anderson Hancock Planetarium

Corner of Fourth and Butler Streets

The planetarium includes a 102-seat theater. Programs focusing on various aspects of the night sky, the solar system and other elements of the cosmos are offered throughout the year. Seating is first come, first served. Reservations are highly recommended. Special advance arrangements can and should be made for groups. Visit the planetarium's website, www.marietta.edu/departments/Planetarium, for a schedule of upcoming programs and for reservation information, or call 740-376-4827.

Marietta College Legacy Library

Fifth Street Mall on the Marietta College Campus

Marietta's new state-of-the-art library opened in January 2009. Please come inside and look around this amazing building. In addition to maintaining the regular academic collections and resources, the library also houses the Marietta College Archives, which contain rare documents, drawings, photos, diaries, letters, maps, paintings and newspapers relating to the history of the college, the town and Washington County, including the papers of Rufus Putnam. Much is available for online viewing and research. Visit the library's website at www.library.marietta.edu or call 740-376-4543 for more information.

Andrews Hall

Fifth Street Mall on the Marietta College Campus

Built in 1891, this grand old building was scheduled for demolition in the 1980s. Students, alumni and townspeople worked together to save it. Andrews Hall was completely renovated and reopened in 1993. It serves as headquarters for various student organizations.

Erwin Hall

Fifth Street Mall on the Marietta College Campus

Completed in 1850, Erwin Hall is the oldest building on campus. Its large clock tower, which contains a carillon, is the college's symbol. The building

was named for C.B. Erwin, an early benefactor. Note the rows of immured chimneys. Erwin Hall was renovated in 1971.

The Marietta College President's House, the Mills House

301 Fifth Street, Fifth and Putnam Streets

This impressive mansion overlooking Putnam Street and the college campus was built about 1822. Prominent businessman and Marietta College treasurer John Mills purchased it in 1836. The Mills family lived in the house until 1937, when it became the Marietta College president's home.

THE RESIDENTIAL DISTRICT

Many of the wonderful houses and other buildings in this part of town were constructed during the late 1800s and early 1900s. They reflect the Victorians' love of flamboyant, elaborate, asymmetrical design. As you make your way through the neighborhood, notice the classical columns, towers, turrets, curving porches, dormers of every conceivable shape, arches, gingerbread trim, stained-glass windows, Gothic spires, buttresses and bays.

Whether you come to see Christmas lights twinkling in the snow, to catch the heavenly scent of an old-fashioned lilac, to escape the summer's heat beneath the shady sycamores or to shuffle through a drift of crimson leaves, enjoy. But please respect people's privacy and personal property. Stay on the sidewalks. Unless noted otherwise, all homes are private residences.

The George White House, Alpha Xi Delta Sorority House

322 Fifth Street

Built in 1855, this house was purchased in 1908 by George White, who served in the U.S. Congress and was governor of Ohio for two terms. The mansion has been a sorority house since 1954.

The Downtown Residential District

The House of Seven Porches

331 Fifth Street

The House of Seven Porches was built in 1835 by Professor D.H. Allen, one of Marietta College's five original professors. He hoped this portion of Fifth Street would become "Faculty Row." Professor Allen moved to Marietta from Charleston, South Carolina, and the house has an elegant, southern feel. Four of its porches are obvious from the street. The remaining three run across the back of the house. The kitchen was located in the basement until a major remolding project in 1995.

St. Paul's Evangelical Church

401 Fifth Street, Corner of Fifth and Scammel Streets

This building dates from 1849, although it has been modified several times. The original church was designed by John Slocomb, the architect of the Castle and the Unitarian church. Formerly known as the German Evangelical Kirche, services were conducted in German until 1909.

MOUND CEMETERY

Directly across Fifth Street from St. Paul's Church lies Mound Cemetery. As strange as it may sound, it is one of the most visited places in Marietta. Nestled in the embrace of the surrounding neighborhood, the cemetery is a historian's paradise. Some of those who rest beneath the weathered stones are famous. The quiet details of others' lives were forgotten long ago. A walk through Mound Cemetery is a walk through Marietta's past. But the cemetery's final chapter has not yet been written. New graves are added every year.

Mound Cemetery began, like so much of Marietta's story, with the arrival of Rufus Putnam and the Ohio Company in 1788. After surveying the area and fine-tuning their carefully drawn plans for the new city, they reserved the one square block around the mound, which they had named Conus, and designated it a public burial ground.

Conus

Conus, the pyramid mound that rises from the center of the cemetery, is an Adena burial mound. It is more than two thousand years old. The Adena were the earlier of the two groups of Mound Builders who created the Marietta earthworks complex. Burial rites were especially important to the Adena, but not everyone was buried in a mound. That honor was reserved for only a few. We do not know if the chosen individuals were rulers, priestesses, magicians, great hunters or healers. Perhaps they were important for reasons we cannot even imagine.

Adena burial mounds are not like Egyptian pyramids. They are not monuments to individuals. Adena mounds contain dozens, maybe hundreds, of people. Each mound began with a single burial. The next time an important person died, his or her body was brought to the site and buried in the mound. Over time, as more and more remains were added, the mound slowly grew larger. Consider that fact as you look at Conus, which is more than thirty feet tall.

The sacred circle around the mound Conus. *Photo by Michael Pingrey.*

The Downtown Residential District

The Conus earthwork includes more than the pyramid mound. It is surrounded by a circular moat, also known as a sacred circle. The moat is part of the original Adena structure, as is the expanse of flat ground between the moat and steep sides of the mound. The earthen bridge that crosses the moat is also an Adena feature. Conus is the only mound with an intact sacred circle in a publically accessible place.

The Cemetery Takes Shape

The first modern person interred in Mound Cemetery was Colonel Robert Taylor, a Revolutionary War veteran, who died in October 1801. Other veterans of America's fight for independence soon followed. Mound Cemetery contains more Revolutionary War officers' graves than any other graveyard in the United States. The number of officers usually quoted is thirty, but that may not be correct. The lack of certainty stems from burial practices in the early 1800s.

In its first days, Mound Cemetery was nothing more than an open field on the outskirts of town. Although it was a public burying ground, it was not laid out with plots and avenues as it is today. People dug graves wherever they wanted, and most graves were unmarked. There was no system for recording the deceased's name, date of death or burial location. With alarming frequency, those attempting to bury relatives in Mound Cemetery found the ground they were digging in already occupied.

In the 1830s, city fathers decided the time had come to impose order on the burial ground. They had paths built, added the stone stairs up the side of Conus and had the mound's top flattened, which reduced its height by about five feet. They also developed a cemetery plan complete with numbered plots. Most importantly, they prohibited members of the public from digging graves. Professional gravediggers were hired for that task.

The new gravediggers did not know where people had already been interred, so they continued to encounter the same problem that had plagued the general public. In addition to finding modern burials in unexpected places, they occasionally uncovered prehistoric artifacts and remains. They found an ancient infant's skeleton in Conus's sacred circle and a cache of arrowheads, highly polished stone axes, a block of silver the size of a brick and a mysterious object that looked like a stone corncob near Tupper Street. The infant was reburied in Oak Grove Cemetery. The arrowheads and other objects disappeared.

The citizens of Marietta appreciated and supported the cemetery improvements, but the basic problem of not knowing who was buried where was not addressed until 1858, the year those responsible for the cemetery began

keeping reliable records. Most of the Revolutionary War veterans had passed away by then. This is why the details of some of their burials are unknown, and the number of officers resting in the cemetery will always be an estimate.

The cluster of small American flags near the wide brick path that leads from the main entrance to the mound is the Daughters of the American Revolution (DAR) Memorial Plot. Each flag honors a Revolutionary War veteran who is buried in Washington County in an unmarked grave. We know the birth and death dates for some; for others, we know only the year of death.

Not all Sons of the Revolution lie in unmarked graves. Many notable Patriots' final resting places are clearly and correctly marked. Rufus Putnam is buried in the cemetery, along with members of his family. So is Commodore Abraham Whipple. For more about Putnam's and Whipple's lives, see chapter one. Of all the Revolutionary War veterans buried in Mound Cemetery, the most unique epitaph belongs to Nathaniel Saltonstall. He served honorably during the war, but his real battle did not begin until after the peace treaties were signed.

Most history books don't mention the Battle of Penobscot Bay, which is odd given the fact that it was the second greatest naval disaster in American history. In 1779, the British navy burned thirty-nine of the forty American vessels sitting in Penobscot Bay, Maine. The lone ship that survived was captured. The inept, indecisive commander of the American naval forces, the man blamed for the debacle, was Dudley Saltonstall, Nathaniel Saltonstall's cousin. Dudley was court-marshaled and became a pirate.

Nathaniel, who bore an unfortunate resemblance to his disgraced cousin, spent the rest of his life making sure no one mistook him for Dudley. The fact that both Saltonstalls had been officers in the Continental navy and both had commanded ships named the *Warren* added to the confusion. Nathaniel's need to assert his identity extended beyond the grave. The words he selected for his Mound Cemetery tombstone are:

In Memory of
Capt. Nathaniel Saltonstall
Born in New London Conn. AD 1727
Died AD 1807
Was 1st Commandant of Fort Trumbull
During the Revolution
He commanded the Warren Frigate and
Ship Putnam but was not Commodore
Of the fleet burned at Penobscot.

The Downtown Residential District

The names of his wife and two children appear at the bottom of the stone, footnotes to his life story.

Exploring the Cemetery

Wandering through the tombstones, stopping to read random names, dates and epitaphs, is an interesting and satisfying way to explore the cemetery. If you want to focus on Revolutionary War veterans, consult the map on the metal sign in front of the mound. It shows the locations of their graves. Another possible approach is to walk the Historic Circuit described below and shown on the chart. The Historic Circuit will take you past some of the most interesting, beautiful and poignant monuments in the graveyard. Regardless of how you choose to explore Mound Cemetery, the following will help you understand this fascinating place.

The oldest section of the cemetery extends from the corner formed by Sixth and Tupper Streets along the Sixth Street fence. The most recent burials are near Fifth Street. Families are together, of course, but other than

The cemetery emblem for a Revolutionary War veteran. "SAR" stands for Sons of the American Revolution. *Photo by Michael Pingrey.*

that, there isn't a strict organization. This has resulted in the wonderful juxtaposition of obelisks, columns, horizontal tabletop monuments and pyramids from different periods. Immigrants who came to the New World long before the American Revolution rest here, their epitaphs chiseled in the languages of the countries they left behind. The shrouded urns, which symbolize deep mourning, are from the Victorian era. Many of the small, plain markers are for those lost in infancy or childhood.

American flags mark all veterans' graves. Each flag is mounted in a bronze holder that includes the emblem of the war in which the veteran served. Mound Cemetery contains many emblems for the Sons of the Revolution. If you look carefully, you will also find veterans of the War of 1812, World War II, Korea and Vietnam. These emblems speak for themselves. The emblem that says "World War" refers to the conflict we call World War I. The five-pointed stars found throughout the graveyard are for Union veterans of the Civil War. "GAR" stands for the Grand Army of the Republic, the Union army's official name. Brothers Charles and George Buck fought in the Civil War and are buried side by side. A GAR Union star supports George's flag; Charles's bronze emblem identifies him as a Confederate War veteran. Other service emblems in the cemetery include the Daughters of the American Revolution, Marietta City firefighters and a few that simply say "U.S. war veteran."

Historic Circuit

A. Begin in front of Conus at the head of the brick walkway. Begin circling the mound in a clockwise direction. As you go along, take a good look at the mound and the surrounding moat or sacred circle. The mound, the moat and the slightly raised berm you are walking on are more than two thousand years old. Feel free to climb the mound, but please use the stairs. Be careful! The steps, installed in the 1830s, are weathered, uneven and quite slippery at times. There are benches on top of the mound, the perfect spot to catch your breath and take in the view. The small stone block that rises out of the center of the observation deck contains a time capsule that was buried on July 3, 1976, to mark the U.S. bicentennial. If future residents of Marietta follow instructions, the capsule will be opened on July 4, 2076. Go back down the stairs and continue walking clockwise until you are about halfway around the mound. Proceed to the large monument for Rufus Putnam and his family.

B. RUFUS PUTNAM: Not only a general during the Revolutionary War, Putnam was the visionary leader of the Ohio Company of Associates, the men who founded Marietta.

The Downtown Residential District

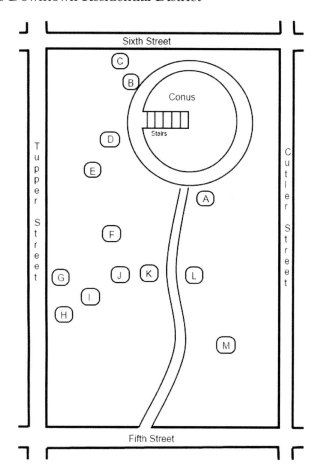

Mound Cemetery Historic Circuit. *Chart by Michael Pingrey.*

C. ROBERT TAYLOR: A Revolutionary War veteran and the first person buried in Mound Cemetery.

D. ABRAHAM WHIPPLE: Commodore of the Continental (American) navy during the Revolutionary War.

E. LUCY PIERCE: This badly weathered square monument with one of its sides tumbled in was erected in 1810. When new, it included a large urn and other decorative elements. The square indentations where the missing pieces sat are clearly visible on the top.

F. NATHANIEL SALTONSTALL: A Revolutionary War veteran often mistaken for his disgraced cousin.

G. WOODBRIDGE FAMILY PLOT: The row of graves and stones partially surrounded by the low iron fence belong to one of Marietta's founding families. Dudley Woodbridge opened the first store in town. Decorative iron

fences used to be common in the cemetery. The Woodbridges' fence, which seems to deteriorate daily, is the only one that remains.

H. RETURN JONATHAN MEIGS JR.: Governor of Ohio (1810–14) and U.S. postmaster general. His house still stands at 326 Front Street (see chapter two).

I. COTTON FAMILY MEMORIAL: The Cotton family's large granite stone stands within view of their home, the elegant white house on the corner of Fifth and Tupper Streets.

J. WARD STONE VAULT: The crumbling sandstone vault behind the DAR Memorial flags was commissioned in 1858 by Nahum Ward, former mayor and benefactor of the local Unitarian church. Mr. Ward is buried at Mound Cemetery, although his remains are not in the Ward Stone Vault.

Prior to the 1880s, funerals were held at home. The deceased remained in the parlor or in his or her bedroom until it was time to take the body to the cemetery. Although the period between death and interment was normally only a few days, occasionally burials had to be delayed. Some families could not proceed until out-of-town relatives arrived. Weather and climate interfered with others' plans. If the death occurred in the middle of winter, for example, interment could be delayed until the frozen ground

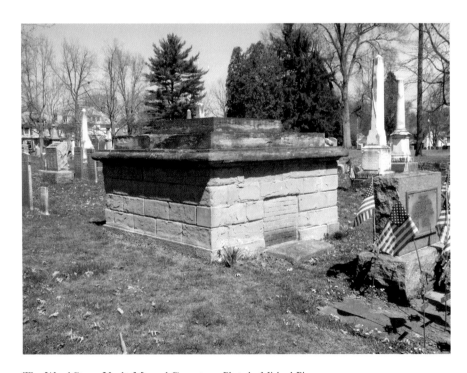

The Ward Stone Vault, Mound Cemetery. *Photo by Michael Pingrey.*

thawed. While mourners and gravediggers waited, there was nowhere to store the body. Much to everyone's relief, Nahum Ward solved the problem by having the large public holding vault built. As funeral parlors became more common, the need for the holding vault decreased and finally ended all together. It served briefly as a toolshed before the opening was sealed to prevent local teenagers from putting the structure to "undesirable uses."

K. DAR Memorial Plot: The rows of flags honor those veterans of the American Revolution who are buried in Washington County in unmarked locations.

L. Charles Frederick and George H. Buck: brothers who fought on opposite sides in the Civil War.

M. Memorial to Martha Brianerd and Her Children: The years have been hard on this once beautiful memorial with its statue of a praying woman. The upper portion of the monument is missing. It used to be surrounded by an ornate iron fence, also gone. The mound the monument sits on is not ancient. The entire structure is Victorian, although it's likely the mound was intended to echo the shape of Conus. This is a family memorial, not a grave site.

People are rightly dismayed by the large number of broken tombstones in the cemetery. Some of the damage can be attributed to time and weather. Some is the result of carelessness on the part of groundskeepers. Discussions about the best way to protect and preserve Mound Cemetery are ongoing.

Return to Fifth Street

Leave Mound Cemetery, turn right and continue north on Fifth Street, away from the college campus. As you make your way from the cemetery toward Washington Street, you pass through the first of two enclosed plazas that were part of the ancient earthworks complex. Nothing remains. Not on the surface anyway. Even though the Mound Builders have been gone for more than fifteen hundred years, residents still occasionally unearth odd things when digging in their gardens.

The Cotton House

412 Fifth Street

The white brick Greek Revival mansion on the corner of Fifth and Tupper Streets was built in 1853. It is named for its first owner, Dr. Josiah D. Cotton,

a local physician who served as a surgeon with the Union army during the Civil War. This serene-looking house has a colorful past. The back section was added in 1884 to accommodate a family with six active children. In the 1920s, a man named Mr. Plummer owned the house. His wife ran a curio shop called "Pandora's Box" out of the rear section. After the Plummers declared bankruptcy, the Cotton House became a Marietta College fraternity house and then a sorority house. In 1984, it was reconverted into a single-family dwelling. During the extensive renovation project, the contractor hid a time capsule somewhere inside the house.

Friendly Competition

427 and 431 Fifth Street

Even in a town filled with beautiful old homes, 427 and 431 Fifth Street stand out. These two fabulous Queen Anne–style homes sit side by side, separated by the green expanse of a well-tended lawn. According to local legend, the original homeowners were locked in a heated competition over whose house was prettier. When one purchased a custom-designed stained-glass window, the other built a tower. The installation of a whimsical dormer led to the addition of a gingerbread-bedecked balcony next door. And so it went. The results are stunning.

Row Houses

436–40 Fifth Street, Corner of Fifth and Wooster Streets

This was the first apartment building in Marietta. Originally known as the Ranger Block, it was built in 1899 to accommodate the influx of workers during the oil boom. It includes nine three-story units. Its bay windows and turrets give it late-Victorian flair.

Washington Street and the Hopewell Grand Plaza

In Rufus Putnam's original plan for Marietta, Washington Street was to be the main boulevard, the most important street in town. That is why it is wider than the others. As soon as you cross Washington Street, you have entered the grand plaza, the larger of the two ancient plazas. The plazas were built by the Hopewell, the second, later group of Mound Builders in the area. The grand

The Downtown Residential District

plaza's earthen walls enclosed fifty grassy acres, a space large enough to hold four Roman Coliseums. Its boundaries corresponded roughly to Washington, Sixth, Third and Camp Streets. The Hopewell brought soil into the plaza to create a level surface. There were no trees inside. Imagine a flat golf course or a well-tended athletic field. The grand plaza contained four flat-topped pyramids. Unlike their Adena ancestors, the Hopewell did not bury their dead in the pyramids. Hopewell pyramids were ceremonial platforms.

The Washington County Public Library

615 Fifth Street

Look closely at the Washington County Public Library at 615 Fifth Street. The "hill" it is sitting on is the Hopewell pyramid Rufus Putnam named the Capitoleum. Mound Cemetery's Conus may be the most magnificent feature in the earthwork complex, but the flat-topped Hopewell pyramids are the most intriguing. People noticed their similarity to the pyramids at

The main branch of the Washington County Public Library sits atop a Hopewell platform mound. *Photo by Michael Pingrey.*

Teotihuacan in Mexico as early as the late 1700s and wondered whether the ancestors of the Aztecs built the Marietta pyramids. When the public library was remolded early in the 1990s, scientists from the Cleveland Museum of Natural History took several samples from the Capitoleum and determined that the mound was built by the Hopewell.

Many people are appalled that a modern building was constructed on an archaeological site. There is no doubt, however, that building the library on the mound kept it from being leveled and the land divided into lots for houses. The children's department and public restrooms are in the library's basement, inside the mound. Visitors are welcome. For more information on library hours and services, visit www.wcplib.lib.oh.us or call 740-373-1057.

The Quadranou and the Sacra Via

Continue down Fifth to Warren Street. Turn left. Walk one block. Cross Warren, cross Fourth and enter the grassy park on your right. The large hill that dominates the park is the Quadranou, another flat-topped Hopewell pyramid mound. Quadranou refers to the mound's four access ramps. The park—the area bounded by Third, Fourth, Warren and Camp Streets—was a troop training area called Camp Tupper during the Civil War. The Quadranou is occasionally referred to as the Tupper Mound.

Feel free to walk around the mound and go on top. When you are standing on the mound, look west, across Third Street and into the middle distance. The tall ridge you see is Harmar Hill. On the winter solstice, about December 21, as the sun sets over the ridge, it illuminates Sacra Via and Warren Street. For a few breathtaking moments, they appear to be on fire. Once scholars recognized the Quadranou's winter solstice orientation, they quickly identified several other astronomical alignments. Archaeologists now agree that the Quadranou was an astronomical observatory and the Hopewell were much more sophisticated than previously thought.

Walk down one of the Quadranou's ancient ramps and cross the park to Third Street. Bear slightly left and cross Third. Sacra Via Street, the twin brick lanes divided by a wide, grassy median that lie ahead of you, is the final element in the Marietta sacred complex. In many ways the most enigmatic, the Sacra Via is also the hardest to discern in the modern landscape. The gently sloping front yards of the houses that line Sacra Via Street are all that remain of the grand corridor.

The Sacra Via was a walled walkway 680 feet long and 150 feet wide. It ran from the Muskingum River bank to the grand plaza that contained the Quadranou and the Capitoleum. Today, Sacra Via Street, along with its

wide median, lies atop the ancient route. The distance from the outside curb on one side of Sacra Via to the outside curb on the other side equals the width of the ancient sacred road.

As stated earlier, archaeologists think people came to Marietta on religious pilgrimages, possibly from great distances. They arrived by canoe, disembarked and entered the walled passageway at the riverbank. They then followed the passageway—their view of the surroundings blocked by the walls—until they emerged in the grand plaza with its magnificent flat-topped pyramids. Walking through the passageway might have been the final stage in a personal transformation or the end of some sort of mystical quest. The details are lost in time, but walking the Sacra Via was clearly an integral part of the magic and mystery of this place.

About the year 500, the Hopewell abandoned the Marietta earthworks. We don't know why. There is no evidence of war, famine, epidemic or ecological disaster. Perhaps the Hopewell adopted a new religion, or maybe the mounds had lost their magical power. Whatever the reason, the earthworks stood lonely and forgotten for more than a thousand years until a young army officer named Jonathan Heart discovered the remains of a lost civilization deep in the American wilderness.

Fourth Street

Return to Fourth Street, turn right and begin making your way back to Putnam Street.

Dawes House

508 Fourth Street

This gabled brick house was built in 1869. Note the porthole window near the peak of the roof. In 1870, it was purchased by Rufus Dawes, a decorated Civil War officer who served in the U.S. Congress. Rufus Dawes's oldest son, Charles Gates Dawes, served as vice president under Calvin Coolidge and was ambassador to England. Charles Gates Dawes was the author of the World War I German reparation plans, for which he won a Nobel Peace Prize. The house remained in the Dawes family until 1968, when it became St. Mary's convent. It became a private residence again in the late 1980s.

There is an odd historical footnote concerning Charles Gates Dawes. He was a self-taught musician and composer. In 1912, he wrote a popular

piano and violin piece called "Melody in A Major," which he had played at many of his official appearances. In the 1950s, lyrics were added to Dawes's instrumental composition, and it was renamed "It's All in the Game." Tommy Edwards's recording of "It's All in the Game" was number one on the American Billboard record charts for six weeks in 1958.

Seventh-Day Adventist Church

505 Fourth Street

A number of denominations have worshipped in this very old church, which was built in 1866. The front façade is a later addition.

St. Mary's Rectory

506 Fourth Street

When this fabulous house was built in 1865 for the president of the Bank of Marietta, it was located on the corner of Fourth and Wooster Streets, the

The Rectory and St. Mary's Catholic Church. *Photo by Michael Pingrey.*

lot now occupied by St. Mary's Catholic Church. From 1890 until 1893, it was the Elizabeth College for Women and was known as Putnam Hall. After the women's school merged with Marietta College, Putnam Hall became a private residence again.

In 1903, the house had to be moved so St. Mary's Church could be built on the corner. A world-famous expert in relocating buildings, Titus de Bobula of Budapest, Hungary, was hired to supervise the project. One hundred men with jacks were strategically positioned around the house. When the foreman blew his whistle, the men lifted the building and lowered it carefully onto logs. Teams of oxen pulled it to its current location. The entire operation proceeded without causing an iota of damage to the house—not a brick out of place, not a cracked pane of glass—another flawless move courtesy of Titus de Bobula.

Now St. Mary's Rectory, this impeccably maintained house exemplifies the Victorian style known as Italianate. The key elements are the square cupola; tall, narrow windows; and broad eaves supported by large, ornate corbels.

St. Mary's Catholic Church

500 Fourth Street

Marietta's first Catholic church was located in the flood plain. The devastating floods of the late 1800s convinced the congregation to relocate and to build on higher ground. Construction on this building began in 1903 and was completed in 1909. When the new church was ready, the parishioners marched from the old flood-prone location to the new—and dry—building singing hymns.

A hodgepodge of styles including Baroque, Gothic, Romanesque and Beaux Arts, Emil Ulhrich, the building's architect, called it Spanish Renaissance. Note the soaring dome with copper-clad walls and twin bell towers. The magnificent stained-glass windows were made in Germany. They were smuggled through the British naval blockade during World War I. The church's historic interior has recently been renovated and cleaned with marvelous results.

First Presbyterian Church

501 Fourth Street, Corner of Fourth and Wooster

Although the large church building on the corner of Fourth and Wooster Streets appears to be relatively new, it was built in 1896. The architectural style is known as Richardson Romanesque. It is reminiscent of a fairy tale castle with its stone walls, rounded arches, pointed windows, Gothic finials and towers.

Shipman-Mills House

430 Fourth Street

This Victorian Gothic home was built in 1852 by John Shipman. The Mills family later purchased the house and owned it for many years, hence its name. Note the decorative bargeboard trim along the gables. The glass in the front windows is original.

The Castle

418 Fourth Street

The Castle, one of the finest Gothic Revival mansions in Ohio, features an octagonal tower, stone-capped spires, crenellated porch roofs, a pointed arch front door, steep asymmetrical gables with crosses and trefoil attic windows. It was designed by John Slocomb, the architect of the Anchorage in Harmar and Henderson Hall in nearby West Virginia. Both the Anchorage and Henderson Hall, which are discussed elsewhere in this book, are Italianate villas. By creating a Gothic-style masterpiece, Slocomb showcased his versatility and great range.

The oldest part of the Castle is the summer kitchen, which was built in 1830. The main house and the detached carriage house were built in 1855. The rooster weather vane on top of the carriage house is original. The iron fence on the Fourth Street sidewalk was installed to keep cows from wandering into the front yard.

In 1887, Edward Nye purchased the Castle. It remained in his family until 1974, when the last Nye descendent died in the house five days before her 100th birthday. Even though decades of neglect had taken a great toll on the

The Downtown Residential District

The Castle. *Photo by Michael Pingrey.*

building, siblings Stewart and Bertalyn Bosley purchased the house and began a twenty-year renovation project. Neither Stewart nor Bertalyn lived to see the work completed. The Castle became a historic house museum in 1994.

The lovely interior is decorated with Victorian-era furniture and art. The Castle hosts musical events, workshops, lectures and special programs for children. It is also open for tours. Several photos of the Castle before the renovations began are on display in the carriage house, which serves as a visitors' center and gift shop. Hours vary by season. There is an admission charge. Visit www.mariettacastle.org or call 740-373-4180.

St. Luke's Lutheran Church

401 Scammel Street, Corner of Fourth and Scammel

The large stone church on the corner of Fourth and Scammel Streets was built in 1901. A late-Victorian design, it contains an assortment of Classical elements, including low-relief columns between the windows. The 1992

addition on Fourth Street blends perfectly with the older part of the church. It was built with green fieldstone taken from the same quarry.

Ely Chapman Center

403 Scammel Street

Take a short, half-block detour up Scammel to see a fantastic old school building. In 1901, with great fanfare, the doors of the new Marietta High School at 403 Scammel Street opened. It was built on the lot previously occupied by the first high school. The new building's design elements included Classical columns, friezes and pediments. It was equipped with all the latest school features, including an electric bell and a speaking tube system that allowed the superintendent to address all the classrooms simultaneously. The school population quickly outgrew its new home. Students and faculty relocated in 1926. The wreaths and torches that decorate the exterior of the building indicate that it is an educational facility, which is still fitting. The building houses the Ely Chapman Center. The old classrooms are used for after-school and summer programs.

First Baptist Church

301 Fourth Street, Corner of Fourth and Putnam Streets

Baptists have been part of Marietta since the settlement's earliest days, but they did not have their own church building until 1836. Unfortunately, it was destroyed by fire in 1855. The congregation built a new church known as the Putnam Building next to the old city hall, about half a block from the current church's location. When the Putnam Building burned in 1906, the massive stone structure on the corner of Fourth and Putnam, across from the Betsey Mills Club, was erected. The pointed red tile roof is visible all over downtown.

The Betsey Mills Club

300 Fourth Street, Corner of Fourth and Putnam Streets

The complex of red brick buildings on the corner of Fourth and Putnam Streets houses the Betsey Mills Club, one of Marietta's most beloved

The Downtown Residential District

institutions. In 1911 a wealthy, reform-minded socialite named Betsey Mills founded an organization for young women called the Girls' Monday Club. The club's purpose was to promote "all-round development in the ambitious, self-respecting girl." To meet this lofty goal, Mrs. Mills and several of her friends allowed sewing and cooking classes to be offered in their homes. The Girls' Monday Club attracted a large following and soon needed a permanent meeting place.

When the frame house on the corner of Fourth and Putnam became available, Mrs. Mills and her husband purchased it and donated it to the club. She had sentimental ties to the property; it had been her childhood home. She and her wealthy friends transformed the old house into the club's headquarters. The Girls' Monday Club continued to thrive, and a few years later, Mr. and Mrs. Mills purchased the house next door and donated it as well.

When Mrs. Mills died in 1920, her husband financed a major expansion of the club's facilities in her memory. The two frame houses on Fourth Street were incorporated into the large brick building we see today. The gymnasium and pool were added at that time. When the project was completed, the Girls' Monday Club voted to change its name to the Betsey Mills Club. The Betsey's facilities, classes and social events are open to all members of the community.

5
THE CAMPUS MARTIUS MUSEUM COMPLEX

Native Americans, Pioneers and Rivermen

The Campus Martius Museum Complex has three main components: the Campus Martius itself, which includes Marietta's history museum, the Rufus Putnam House and the Ohio Company Land Office; the three buildings and outdoor exhibits of the Ohio River Museum; and the *W.P. Snyder Jr.*, a floating National Historic Landmark, the last steam-powered towboat in existence. The *Valley Gem*, a modern stern-wheeler excursion vessel moored next to the *W.P. Snyder Jr.*, is also described below.

The Campus Martius recently faced a serious funding crisis. When the Ohio Historical Society reduced its support, the museum was in danger of closing. Citizens of Marietta who believe the town's history is important and worth preserving worked together and found a way to keep the museum's doors open. On the heels of their successful grass-roots efforts, the American Association of Museums awarded accreditation to Campus Martius, an honor achieved by only 4.5 percent of American museums.

CAMPUS MARTIUS

Campus Martius, which is Latin for "Mars Field," is named for and located on the site previously occupied by an enormous fort. The Ohio Company began construction of the Campus Martius fort in 1788. It was a hollow square approximately 180 feet on each side with a blockhouse on each corner. The fort could accommodate fifty or sixty families in times of emergency.

The Campus Martius Museum Complex

During the Indian Wars (1790–94), many Marietta residents took cover inside Campus Martius. But protection was not the fort's only function. It served as the Ohio Company's headquarters. The first law courts in the Northwest Territory convened within its walls. Church services and classes for schoolchildren were held inside as well. Visitors can see a scale model of the fort in today's Campus Martius Museum.

In 1931, the museum was built over and around Rufus Putnam's house, the last part of the original fort still standing. The house is completely enclosed within the museum and is open to visitors. Incredibly, several pieces of the Putnam family's furniture and other belongings are on display inside their home.

The other significant building on the museum grounds is the Ohio Company Land Office. Also open to visitors, the Land Office is the oldest building in Ohio. Built in 1788, it was moved to the museum grounds in 1953. The Land Office was where the Ohio Company created the earliest maps of the Northwest Territory and issued deeds to settlers.

These two old buildings are fascinating, but there is much more to see at Campus Martius. Near the front entrance is a scale model of the ancient

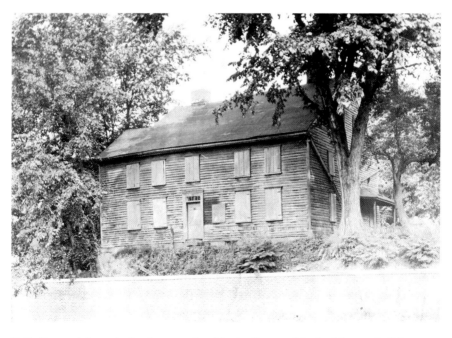

Rufus Putnam's house before it was enclosed in the Campus Martius Museum building. *Courtesy of the Washington County Historical Society.*

earthworks complex as it appeared when Rufus Putnam and the Ohio Company first saw it in 1788. Displays on the main floor include a wide range of Native American artifacts from Adena and Hopewell times through the historic period. Most of the exhibits on the main floor, however, focus on various aspects of life in early Marietta. Visitors see clothing, toys, kitchen utensils, tools, guns and the contents of a doctor's bag. Several rare items from the doomed Blennerhassett Mansion, completely destroyed by fire in 1811, are also on display. Exhibits rotate and change regularly. For example, at the time of this writing, a large Civil War exhibit is being set up on the second floor. Check with the museum for information on current displays.

The museum's entire lower level is devoted to an exhibit called Paradise Found and Lost. It explores the social upheaval that accompanied the migration of rural Appalachian people to Ohio's industrial centers beginning in the middle of the nineteenth century. The displays include audio, video and interactive elements. The exhibit is different from anything else in the museum and is worth visiting.

Campus Martius is located at 601 Second Street, on the corner of Washington and Second. The museum is closed on Tuesdays. On Monday, Wednesday, Thursday, Friday and Saturday, it is open from 9:30 a.m. to 5:00 p.m. It is open Sunday from noon until 5:00 p.m. and is closed on Easter, Thanksgiving, Christmas and New Years Day. Appointments can and should be made for groups. Hours and days of operation are subject to change. Please call to confirm.

There is an admission charge for Campus Martius. One-day combination passes for both Campus Martius and the Ohio River Museum are available. Ask about discounts to the Blennerhassett Museum of Regional History in Parkersburg. See chapter eight for more information on the Parkersburg facility. There is plenty of free parking at Campus Martius. Visit www.campusmartiusmuseum.org or call 740-373-3750 or 800-860-0145 for more information.

Ohio River Museum

There are two things visitors should know about the Ohio River Museum. The first relates to its location. The Ohio River Museum is not on the Ohio River; it is on the Muskingum River a block west of Campus Martius at the intersection of Front and St. Clair Streets. The second relates to the nature of the museum's exhibits. Although there is a small display on the

natural history of the Ohio River, the museum's main focus is the golden age of steamboats. Those interested in biodiversity, ecology and conservation should consider visiting the Ohio River Islands National Wildlife Refuge, a free facility less than five miles away. For information on the Ohio River Islands National Wildlife Refuge, see chapter seven.

The Ohio River Museum includes three buildings connected by elevated walkways, several interesting outdoor features and the historic towboat the *W.P. Snyder Jr.* The first building houses the ticket office and an exhibit on the various animals that make the river their home. The second building showcases the extensive collection of the Sons and Daughters of Pioneer Rivermen. Boat whistles, signs, crew uniforms, fancy furniture, silver serving pieces, vintage photos, scale models and more are all tastefully displayed. There is also a video about the days when steam was king. The third building contains tools and equipment from the steamboat era, as well as an exhibit on the mussels that live in the river.

Be sure to visit the outdoor part of the museum where you'll see poles marking the depths of Marietta's worst floods, the pilothouse from the steamboat the *Tell City* and a replica of a flatboat, the type Rufus Putnam and the men of the Ohio Company sailed to Marietta.

THE *W.P. SNYDER JR.* STEAMBOAT—MUSKINGUM RIVER

Moored in the Muskingum River and part of the Ohio River Museum, the *W.P. Snyder Jr.* is the last stern-wheeler steam-powered towboat in existence. A National Historic Landmark, it was part of the Carnegie Steel corporation fleet. Built in 1918, the boat towed coal, iron and steel up and down the Monongahela River until 1953. In 1955, the *W.P. Snyder Jr.* was given to the Ohio Historical Society so that the boat could be exhibited in Marietta.

The *Snyder*, as it is fondly known, underwent extensive renovations in 2009 and 2010. It traveled to South Point, Ohio, for the last round of renovations. When the project was completed, the people of Marietta turned out and lined the riverbanks to welcome the *Snyder* home. For many steamboat enthusiasts, the *W.P. Snyder Jr.* is the highpoint of their visit to Marietta.

The Ohio River Museum and *W.P. Snyder Jr.* steamboat are located at Front and St. Clair Streets on the Muskingum River. Operating hours are the same as for Campus Martius. The museum is closed on Tuesdays. On Monday, Wednesday, Thursday, Friday and Saturday, it is open from 9:30 a.m. to 5:00 p.m. It is open Sunday from noon until 5:00 p.m. and is closed

A Guide to Historic Marietta, Ohio

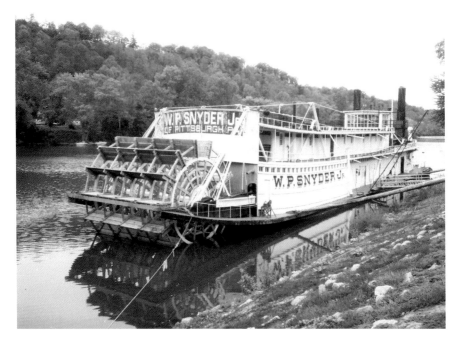

The *W.P. Snyder Jr.* is the last steam-powered towboat in existence. *Photo by Michael Pingrey.*

on Easter, Thanksgiving, Christmas and New Years Day. Appointments can and should be made for groups. Hours and days of operation are subject to change. Please call to confirm. Occasionally, high water makes the *Snyder* inaccessible. Check with the museum for current river conditions.

There is an admission charge for the Ohio River Museum, which includes a guided tour of the *W.P. Snyder Jr.* steamboat. For more information, visit the Campus Martius website, www.campusmartiusmuseum.org, and click on the Ohio River Museum or the picture of the *W.P. Snyder Jr.* or call 740-373-3750 or 800-860-0145.

The *Valley Gem* Sternwheeler—Muskingum River

The *Valley Gem* offers public excursions on the Ohio and the Muskingum Rivers. A cruise is the perfect way to experience the inland waterways and get a different view of Marietta, Harmar, Williamstown and Buckley's Island. The *Valley Gem* is called a stern-wheeler because its paddlewheel is located at

The Campus Martius Museum Complex

the back, or stern. The boat is not equipped with thrusters or propellers. The rear paddlewheel is the *Valley Gem*'s only means of propulsion.

The *Valley Gem* can accommodate up to 296 passengers. It has an open upper sun deck and a lower enclosed, air-conditioned deck. The lower deck is handicap accessible. There are restrooms, as well as a gift and snack shop, on board. The *Valley Gem* is U.S. Coast Guard approved.

Excursions with live commentary operate from April through mid-November. Special programs include dinner and sunset sailings and the very popular fall foliage cruises through the hand-cranked Muskingum River locks. The boat is available for private charter and is frequently booked well in advance. Reservations are highly recommended.

The *Valley Gem* is docked on the Muskingum River next to the *W.P. Snyder Jr.* steamboat, near the Ohio River Museum, under the Washington Street Bridge. The address is 601 Front Street. There is free parking on-site. For reservations and information, call 740-373-7682 or visit www.valleygemsternwheeler.com.

6
THE APPALACHIAN COUNTRYSIDE

Belpre, Scenic Byways and the Wayne National Forest

BELPRE—OHIO'S SECOND-OLDEST SETTLEMENT

Established in 1789, one year after Marietta, Belpre is the second-oldest settlement in the Northwest Territory. The town was named Belle Prairie because of its rich farmland. Later, the name was shortened to Belpre. During the Indian Wars of 1790–94, the settlers lived in a large fort called the Farmers' Castle. The first library in the Northwest Territory was in Belpre, and the town was the home of Bathsheba Rouse, Ohio's first female schoolteacher. As mentioned in chapter one, the residents of Belpre helped hundreds if not thousands of fugitive slaves make their way north along the secret routes of the Underground Railroad.

The best place to delve into Belpre's history is the Farmers' Castle Museum and Education Center, operated by the Belpre Historical Society. Documents and objects from the town's long past are on display. The collection includes many Indian arrowheads and other artifacts. The museum also houses the Southeastern Ohio Underground Railroad exhibit. Farmers' Castle Museum and Education Center is open April through September on Wednesday and Saturday afternoons. Groups can make arrangements to visit at other times. Opening days and times are subject to change. For current information, please visit www.belprehistory.org or call 740-423-7588.

The Appalachian Countryside

Directions from Marietta to Farmers' Castle Museum and Education Center in Belpre

Take Second or Third Street out of downtown Marietta to Washington Street. Turn left on Washington. Take the Washington Street Bridge across the Muskingum River.
You are now on Ohio Route 7 South.
Follow Route 7 South to Belpre, eleven miles from Marietta.
When you reach Belpre, take the Parkersburg-Belpre exit on the right.
The exit ramp becomes Main Street, which is also Route 618.
Stay on 618 as it turns right off Main and becomes Washington Boulevard. Get in the left lane and follow Washington Boulevard to Locust Street, only a few short blocks. There is no traffic light at Locust Street. Maple Street is the cross street before Locust. Belpre Furniture Galleries is on the corner of Washington Boulevard and Locust Street.
Turn left and follow Locust one block to Ridge, where it ends at the museum. Farmers' Castle Museum and Education Center's physical address is 509 Ridge Street.

A Scenic Trip through Rural History

Although Route 7 between Marietta and Belpre parallels the Ohio River for most of the way, few would describe the drive as scenic. The chemical plants that line the highway employ many people and contribute much to the local economy. They do not, however, add visual appeal to the landscape. For natural beauty, you need to head in the opposite direction. This beautiful drive takes you into the Wayne National Forest, past family farms and country churches, over ridge tops and through tiny villages that are little more than clusters of houses. The route includes portions of two officially designated scenic byways: the Covered Bridge Scenic Byway and the Ohio River Scenic Byway. If you are traveling by motorcycle, prepare for one of the best rides of your life.

Ohio State Route 26 between Marietta and Woodsfield is known as the Covered Bridge Scenic Byway. *Car and Driver Magazine* called it "one of the best driving roads in America," and *Life* magazine included it in the nation's "Top 40 Most Scenic Drives." The route curves in and out of the Wayne National Forest, past historic homesteads and covered bridges. The ride, which parallels the Little Muskingum River for much of the way, is beautiful year-round. The emerald coolness of the forest in midsummer is refreshing,

and in early spring, when daffodils, violets and dogwoods burst into bloom, it is pure enchantment. But for most people, nothing tops the brilliant fall colors of the maple-covered hills. To celebrate peak leaf-viewing season, which occurs in mid-October, an autumn festival is set up along the route for one glorious weekend. Everyone drives slowly, admiring the trees and stopping for cornbread and bean soup, to play old-fashioned country games and to buy handmade crafts and baked goods. Contact the Marietta–Washington County Convention and Visitors Bureau for more details and specific dates of the fall foliage celebration. Approach this drive with caution during winter months. Snow and ice make the road treacherous and impassable at times.

State Routes 26 and 260's *S* curves, hills and dips are much loved by motorcyclists and those who enjoy a challenging country drive. There are no gas stations, restaurants or modern restrooms until you reach Route 7, which will be an hour or more after you leave town, depending on how often you stop along the way. Plan accordingly.

To start your driving adventure, pick up State Route 26 in Marietta. Take Greene Street, which is also State Route 7, north from downtown to the intersection with Seventh Street. There is a traffic light. Turn left onto Seventh and then take an immediate right onto Route 26 north, which is another segment of Greene. There are signs.

Don't rush through this tour. Drive fast enough to enjoy the dips and curves, certainly—that's part of the appeal of this trip—but keep an eye out for other drivers who may be distracted by the scenery, motorcyclists, slow-moving farm equipment, bicyclists and wildlife. You are likely to see many small mammals such as squirrels, rabbits, chipmunks and foxes. You may see deer, wild turkeys and hawks. There are plenty of domestic animals, too. Horses, serene cows and the occasional llama graze on the banks of the Little Muskingum or rest beneath shady trees. Shaggy farm dogs lope along the road, keeping a watchful eye on them all.

The first point of interest is the Hills Covered Bridge. About five miles outside Marietta, turn right onto County Road 333, also known as Hills Bridge Road. The covered bridge is less than half a mile away on the left. Turn left on Zion Ridge Road, pull up next to the bridge and park. The Hills Covered Bridge was built in 1878. It is a pedestrian-only bridge. Feel free to step inside.

According to Wayne National Forest staff, in the old days, many people called covered bridges "kissing bridges" because their dark interiors were conducive to romance. They were also known as wishing bridges. Once you are inside, close your eyes and wish for something incredible. But don't tell anyone the details or your wish will not come true.

The Appalachian Countryside

Return to State Route 26, turn right and continue north into the Wayne National Forest. The first village you encounter is Sitka. The residents pronounce it "Sitkee." Every now and then you'll see a few tumbled-down tombstones, the last remnants of old country cemeteries. There are plenty of gravel pull-offs all along Route 26 if you get the urge to get out of the car.

Next up is tiny Moss Run. Notice the "Mail Pouch Tobacco" sign painted on the barn on the right side of the road. This sign, along with many others in this part of the state, dates from the 1940s. The signs were painted by a local man named Harley Warwick. Like the ghost ads that cling to the bricks in downtown Marietta, the Mail Pouch signs were the billboards of their time. They are now considered historic works of art.

Continue on through the little town of Dart, with its red brick Lawrence Elementary School on the right. A few miles farther, you'll see an official brown Wayne National Forest sign on the right side of the road. The sign says, "Hune Ridge Campground." Slow down. The Hune Covered Bridge is just beyond the sign. You can drive through this bridge, which dates from 1879.

There is a small rest area on the other side of the Hune Bridge, a great place to stretch your legs. When you exit the bridge, continue for another hundred yards or so. Turn right onto the gravel road at the "Canoe Access" sign and cross the creek. There are picnic tables under the trees, a public outhouse and one of the oil wells that dot the fields and riverbank. The oil well is idle. You can take a good, close look at it.

Before you pull back onto Route 26, look to your immediate right on the other side of the road. The large white house beyond the barns is the Hune

The Hune Covered Bridge. *Photo by Michael Pingrey.*

House, one of Route 26's historical homesteads. The house's two sections are completely different styles. The first section was built in 1865 and the second in 1879, the same year as the Hune Covered Bridge.

The next point of interest is Myers General Store, on the left side of the road in the village of Wingett Run. Opened in the 1890s, for many years it had the only telephone in the area. It has been closed since 2004.

In just a little over a mile, you'll come to the last covered bridge on this tour, the Rinard Covered Bridge, which is obvious on your right. The original Rinard Covered Bridge, built in 1875, was destroyed by a flood in 2004. The bridge you see today was built in 2006. You can drive on it.

The next little town is Bloomfield. This is where you pick up State Route 260 South to New Matamoras. Route 260 snakes up and over the ridge tops of the Wayne National Forest, and the views are awesome. Route 260 ends at Route 7 in New Matamoras, ten miles away. When you reach that intersection, turn right and take Route 7 South to Marietta. The thirty miles back to town are part of the Ohio River Scenic Byway, and the glimpses of the river and the West Virginia hills on the opposite bank are lovely.

Even though Route 7 is more developed than Routes 26 and 260, it also passes through parts of the Wayne National Forest. You'll see signs for several trailheads along the river, but you'll also see gas stations, restroom stops and places to grab a sandwich, a beer or an ice cream cone. In summer and early autumn, Route 7 is lined with farm stands selling just-picked sweet corn, strawberries, cantaloupes, juicy tomatoes and fresh flowers.

As you get closer to Marietta, you'll pass two enormous man-made structures. Neither is attractive, but both are interesting. The first is the Willow Island Power Plant. Because of the two large cooling towers, many erroneously assume that this is a nuclear plant. It is not. It is coal fired. In 1978, Willow Island was the site of the worst construction accident in U.S. history. Fifty-one workers died when the tower they were building collapsed. A few miles beyond the power plant are the Willow Island Locks and Dam, operated by the U.S. Army Corps of Engineers.

THE WAYNE NATIONAL FOREST

For information on hiking, camping and other recreational opportunities in Ohio's only national forest, contact the staff at the Athens Ranger District Office of the Wayne National Forest. Call 740-373-9055 or visit www.usda.gov/wayne.

7
WILLIAMSTOWN

*Fenton Glass, Henderson Hall
and the Ohio River Islands National Wildlife Refuge*

Williamstown, West Virginia, lies directly across the Ohio River from Marietta. Many casual observers mistakenly assume that Marietta and Williamstown are essentially a single community divided by the river, just like Marietta and Harmar. That is not the case. Marietta's and Williamstown's stories are entwined, but they are separate and distinct towns, and that has been true from the very beginning.

First Families

In the 1750s, before the American Revolution and decades prior to Marietta's founding, Britain and France went to war over land claims in the Ohio Valley and other parts of the North American frontier. The dispute is known as the French and Indian War because the Native Americans sided with France in the fight against Britain. When the war began in 1754, Isaac Williams, Williamstown's namesake, was eighteen years old. Isaac grew up in the western wilderness, near what is now Winchester, Virginia. He could neither read nor write, but he was a clever and skilled outdoorsman. The British hired him to fight Indians and to serve as a scout, ranger and spy. After the war, Isaac traveled throughout the Ohio and Mississippi Valleys, trapping and hunting. Along the way, he made several tomahawk claims.

Tomahawk claims were a legal way to establish landownership in the Virginia wilderness. The would-be landowner made deep cuts in trees on each corner of

the plot of land he was claiming. The damaged trees marked the boundaries of his property. Tomahawk claims could cover up to four hundred acres. The claims could be sold for huge profits, and that is precisely what Isaac Williams did.

Isaac wasn't the only one making tomahawk claims in Virginia. In 1770, a young man named Samuel Tomlinson arrived in the area that is now Williamstown, hacked his initials into a beech tree and declared himself the owner of four hundred acres facing the mouth of the Muskingum River. Samuel and his brother returned the following spring, built a log cabin and began clearing the land. While they were felling trees and planting corn, their younger sister Rebecca was struggling to cope with the death of her husband, who had been killed by a marauding party of Indians. The brothers invited the sixteen-year-old widow to come and help them work the land. The invitation was not a sentimental gesture. Rebecca was tough, smart and tireless. In addition to hunting, fishing, clearing underbrush and chopping down trees, she did the washing, cleaned the cabin and cooked. She often spent weeks alone and traveled the rivers and creeks of the wilderness in her own canoe. Her assistance was so valuable that Samuel officially transferred his four-hundred-acre tomahawk claim to her.

When a friend introduced Isaac Williams to Rebecca, Isaac knew he'd found his perfect match. They had much in common, including a dislike of fancy clothes. Nevertheless, they both dressed up for their 1775 wedding. She wore a homespun dress, and he wore his hunting clothes.

The Tomlinson brothers and the newlyweds worked the land intermittently over the next few years, but progress was painfully slow. It was a dangerous and unsettled time. Indian attacks were on the increase, and the American Revolution was underway.

By 1787, the situation had improved. Although deadly Indian attacks were still a threat, Isaac and Rebecca decided to move their five young children to her tract of land opposite the Muskingum River, the tract Rebecca's brother had transferred to her. Several other families chose to accompany them. The group established the settlement that became Williamstown in March 1787, a full year before Rufus Putnam and the Ohio Company arrived.

The Williams family and their neighbors were pleased when people began settling across the river in Marietta. Isaac operated a ferry between the two settlements, and there was plenty of friendly mingling. Marietta's founders were creative, resourceful people, but they knew next to nothing about surviving on the frontier. By the spring of 1790, the settlers on the Ohio side of the river were in serious trouble. They had suffered through crop failures, horrible weather and a lack of game. Mass starvation was a real possibility.

Williamstown

Isaac and Rebecca Williams, on the other hand, had plenty of food. Unlike the Marietta settlers, they understood the area's weather patterns and knew the signs of the changing seasons. They had successfully harvested their crops in the fall, and Isaac could always find game. Isaac could have charged the people in Marietta an outrageous price for his corn, and they would have happily paid it. But instead, he shared his corn with his starving neighbors. Isaac made sure that even those who could not pay had enough. He saved their lives.

There was one other difference between the way the Marietta settlers worked their farms and the way Isaac and Rebecca Williams managed theirs. The Williamses owned slaves. Thanks in large part to slave labor, their humble homestead evolved into the most pleasant and attractive plantation in the valley.

At age eighty-three, Isaac became seriously ill. When even Rebecca's considerable healing skills could not restore his strength, the couple sent for an Episcopal minister from Marietta. Isaac asked the minister to preach his funeral sermon then and there. He said the words wouldn't do him any good if they were spoken after he died.

According to Isaac's will, the family's slaves were to be freed upon Rebecca's death. Rebecca freed them all before her husband's body was in the ground. She died five years later, in 1825.

THE HENDERSONS

Alexander Henderson migrated from Scotland to Virginia in 1756 and bought thousands of acres of land in what became West Virginia. About 1800, two of his sons, John G. and Alexander Jr., arrived in the Williamstown area to settle on the family's vast holdings. It wasn't long before the Hendersons were one of the most influential families in the mid-Ohio Valley.

The Henderson brothers were loyal friends of President Thomas Jefferson, and they played a pivotal role in exposing Aaron Burr and Harman Blennerhassett's alleged plot to undermine the U.S. government. Not only did they alert the authorities to what they considered suspicious behavior, but they also testified for the prosecution at Burr's treason trial. The details of the Burr affair are described in chapter eight.

George Washington Henderson, the son of Alexander Jr., married Elizabeth Ann Tomlinson. Elizabeth was related to Rebecca Williams and Samuel Tomlinson, the man who made the original Williamstown-area

tomahawk claim. In 1836, George Washington and Elizabeth Henderson built a modest brick home overlooking the Ohio River.

The waterway had become much more than the scenic boundary between Ohio and Virginia. The river divided the free states of the North from the southern slave states. The citizens of Williamstown and Marietta lived on opposite sides of a cultural and philosophical fault line that was threatening to destroy the nation. On the southern riverbank, Virginia's gentleman farmers, with their prosperous plantations, lovely homes and cultured wives, were determined to defend their way of life, including the right to own slaves. Less than a mile away, on the Ohio's northern bank, an intense and bombastic band of Marietta abolitionists vowed to do whatever it took to force an end to human bondage.

In 1847, George Washington Henderson sued Marietta resident David Putnam in the U.S. District Court in Columbus, Ohio. The suit alleged that Putnam—who was openly active in the Underground Railroad—had trespassed onto Henderson's property and assisted nine slaves to escape in violation of the Fugitive Slave Act. Henderson sought the return of his property or financial compensation for his loss. The bitter and divisive case dragged on until 1852, when it was dismissed by the court.

Although most Virginians believed in slavery, many living in the western portion of the enormous state did not want to see the Union dissolved. Nevertheless, Virginia seceded in 1861, and Richmond became the capital of the Confederate States of America. The following year, delegates from western Virginia, including George Washington Henderson, gathered in Wheeling. They voted to secede from Virginia, to form a new state and to rejoin the Union. West Virginia officially became a state in 1863.

Henderson Hall

In the 1850s, while tensions between northern and southern states mounted, the Hendersons began planning an elaborate and elegant new home. They hired Marietta architect John Slocomb, who designed the Castle and the Anchorage, and asked him to create a three-story Italianate mansion. Slocomb incorporated a portion of the Hendersons' small brick house into the final design. It became the rear section of the villa known as Henderson Hall. Construction was completed in 1859. The heavy work was done by slaves.

Incredibly, an unbroken line of Henderson descendants occupied Henderson Hall until 2007, when the last resident passed away. The house, the family cemetery, several outbuildings and sixty surrounding acres are listed

Williamstown

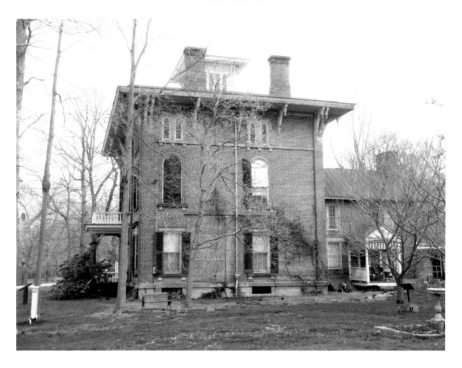

Henderson Hall. *Photo by Michael Pingrey.*

on the National Register of Historic Places as the Henderson Hall Historic District. The slave quarters were destroyed long ago, and their location remains a mystery. Three small Indian mounds stand near the mansion.

The simple fact that the house still exists is amazing. But it is the contents of Henderson Hall that are nothing short of astonishing. The Hendersons—from Elizabeth and George Washington Henderson in 1836 through David in 2007—kept everything. Once something entered Henderson Hall, it stayed. The entire house—from the basement to the third-floor rafters—was crammed with letters, newspapers, books, grocery lists, birthday cards, clothes, hats, magazines, Christmas ornaments, dishes, knickknacks and trinkets from every period of American history. When the interior lighting was converted from gas to electric, all the old light fixtures were piled against a wall in the basement. They're still there. So are the bouquets of fabric roses that were tacked onto the Victorian drapes during the Great Depression. The furniture hasn't been rearranged in one hundred years. The final occupant was fond of pointing out that the drop-leaf tables, velvet settees and tufted ottomans that fill the rooms were purchased new. They became antiques as they sat in the house.

Volunteers are sifting, sorting and cataloguing the Hendersons' belongings and papers. It is a slow process that cannot be rushed. Henderson treasures include a land grant signed by Patrick Henry, George Washington's funeral announcement and a handbill urging voters to reelect Abraham Lincoln. Each time the staff opens a boxful of documents, everyone holds their breath. A tattered letter recently slipped from between the pages of an old Bible. It was written by a Pennsylvania man a few days after Fort Sumter was fired upon. He wonders how "Old Abe" will weather the storm. Truckloads of material have been removed from the house. Most visitors, however, have a hard time believing anything has been touched since the Spanish-American War.

Touring Henderson Hall is not like visiting a re-created, idealized museum house. It's like sneaking into your eccentric aunt's attic while she's next door feeding the neighbor's cat. You have the distinct feeling that the owners are going to return at any moment. Quirky, authentic and intriguing, Henderson Hall provides an unedited glimpse into America's past—peculiar lampshades, faded fabric roses and all. Henderson Hall is open daily. There is an admission charge. Driving directions and contact information appear at the end of this chapter.

Fenton Art Glass

The residents of Marietta and Williamstown have shared many events, including floods, droughts, blizzards, fear of a Rebel invasion during the Civil War and the economic and population boom brought on by the discovery of oil and natural gas in the late 1800s. In 1903, the first bridge over the Ohio River linking the two communities opened, and the neighborly mingling that began in the days of Isaac Williams and Rufus Putnam became even easier. Marietta and Williamstown may share a common past, but one event impacted Williamstown alone: the arrival of the Fenton brothers in 1906.

Colorful art glass was all the rage in the early years of the twentieth century, and Frank and John Fenton were talented glass painters and designers. They were also shrewd, ambitious businessmen. After working for a series of glass companies, the brothers opened their own studio in Martins Ferry, Ohio, where they painted designs on glass blanks that they purchased from various suppliers. When they couldn't obtain enough blank glass items to keep up with customer demand, they decided to open their own glass factory, and they chose to build it in Williamstown. The first piece

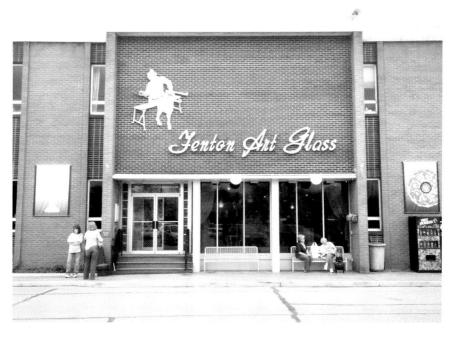

The Fenton Art Glass gift shop. *Photo by Michael Pingrey.*

of Fenton glass was completed on January 2, 1907. Later that year, the Fentons introduced iridescent ware. Carnival glass, as it came to be known, was an immediate sensation. It remains highly collectable more than one hundred years later.

The company has experienced plenty of ups and downs over the last century: two world wars, economic recessions, the Great Depression and ongoing competition from overseas manufacturers. But Fenton survived, and today it is America's oldest and largest producer of handmade colored art glass.

Fenton's Williamstown operation includes the factory, a museum, design studios and a large gift shop. Free tours, including demonstrations of how glass is blown, shaped and pressed into marvelous forms, are offered on a regular basis. The Fenton factory tour was chosen as one of the Top Ten Tours in America by *USA Today* and was also a Rand McNally "Best of the Road" editor's pick. Fenton's tour schedule and opening hours for the gift shop and museum vary by season, but admission is always free. Driving directions and contact information appear at the end of this chapter.

A Guide to Historic Marietta, Ohio

The Ohio River Islands National Wildlife Refuge

Begun in 1990, the Ohio River Islands National Wildlife Refuge is administered by the U.S. Fish and Wildlife Service, part of the U.S. Department of the Interior. The twenty-two islands included in the refuge are scattered along 362 miles of the Ohio River and include two islands in Pennsylvania, two in Kentucky and eighteen islands and three mainland tracts in West Virginia. One of the mainland tracts, as well as the refuge's headquarters and visitors' center, are located two miles outside Williamstown.

The refuge provides and protects natural habitats for more than two hundred species of birds, more than one hundred species of fish and forty species of freshwater mussels, including two endangered varieties. The visitors' center shows a short video that explains what the Fish and Wildlife Service is trying to accomplish with the refuge. There is a live animal exhibit, which includes turtles in natural habitats and a twelve-hundred-gallon aquarium containing several species of fish found in the Ohio River. The visitors' center is not only attractive, clean and well-maintained, but it is also a green facility. The building relies on geothermal energy and solar panels for heating and cooling. Many parts of the structure are made from recycled products. In 2009, the center won a national award for energy efficiency.

There are walking trails throughout the refuge, including the newly redesigned Upland Hiking Trail, which winds up the wooded hillside across Waverly Road from the visitors' center. An easy to moderately difficult hike, the trail leads to a hilltop overlook where you can rest and take in the great river views. The visitors' center has backpacks and binoculars that hikers can borrow at no charge.

A peaceful bird observation area furnished with comfortable Adirondack chairs lies just off the visitors' center lobby. Birdfeeders hang from the branches of many of the trees that surround the building, so you will see and hear a wide variety of songbirds. You are also likely to spot waterfowl along the riverbank. There is a large gazebo with benches near the parking lot, and you are welcome to sit there, too. Grab a pair of the center's binoculars to make sure you don't miss a thing.

The Ohio River Islands National Wildlife Refuge offers special programs throughout the spring, summer and fall, some of which are designed especially for young people. Each October, the facility throws a big party called the River Refuge Festival to celebrate its anniversary. Check the events section of the refuge's website for information on upcoming programs. All

events at the refuge are free. Hunting and fishing are permitted within the refuge, although special permits are needed. Check the website for more information. Directions and contact information appear below.

Williamstown Directions

To visit Williamstown, Fenton, Henderson Hall and/or the Ohio River Islands National Wildlife Refuge, take the Williamstown Bridge across the Ohio River. Turn onto the bridge ramp from Greene Street, which is also Ohio Route 7, at Don Drumm Stadium, the Marietta College/High School football stadium. The stadium runs along Greene Street between Fourth and Sixth Streets. There is a traffic light, and the bridge and access ramp are clearly marked. As soon as your car is on the bridge, you have left the Buckeye State and entered Wild and Wonderful West Virginia. The border is not in the middle of the bridge but at the Ohio River's northern bank.

To Reach Fenton and Henderson Hall

After you cross the bridge, keep going straight. Cross the railroad tracks and get into the right lane. Turn right at the traffic light onto West Virginia Route 14 South toward Vienna. Beautiful Route 14 parallels the river, just like State Route 7 in Ohio.

To reach Fenton, follow Route 14 approximately one half mile to Henderson Avenue. There is a traffic light and a big Fenton Glass sign at the intersection. Turn left. Fenton is a few long blocks through a residential neighborhood, straight down Henderson Avenue. The facility is on your right. There is plenty of convenient, free parking. Fenton Art Glass is located at 700 Elizabeth Street. Visit www.fentonartglass.com or call 304-375-6122 for more information.

To reach Henderson Hall, follow the directions for Fenton, but do not turn off on Henderson Avenue. Continue on 14 South past the Hino truck factory to the Henderson Hall turnoff, which is only two miles from the traffic light at the foot of the Williamstown Bridge where you initially picked up Route 14. The road to Henderson Hall branches off to the right. There are signs. Follow the paved road to the mansion, which is about a half a mile farther on your left. The parking lot entrance is just beyond the house. Henderson Hall's address is 517 Old River Road. For more information, call 304-375-2129.

A Guide to Historic Marietta, Ohio

To Reach the Ohio River Islands National Wildlife Refuge

After you cross the Williamstown Bridge and the railroad tracks, get in the left lane and go straight through the traffic light. Turn left at the next road, which is Waverly Road and also County Road 1. There are Wildlife Refuge signs at the turnoff. The Administration and Visitors' Facility is two miles down this curvy country road on your left. The refuge is open one hour before sunrise to one hour after sunset, Monday through Saturday, from April through October. From November through March, it is open from one hour before sunrise to one hour after sunset, Monday through Friday. The refuge is closed on Sundays and on all federal holidays. The visitors' center is located at 3982 Waverly Road. For more information, call 304-375-2923 or 800-828-1140 or visit www.fws.gov/northeast/ohioriverislands.

8
Blennerhassett Island

Glamour and Treason

Few of the weary settlers traveling down the Ohio River aboard flimsy boats in the early 1800s were prepared for their first glimpse of the house on Blennerhassett Island. The glorious white palace with its twin curved porticoes and sweeping green lawn was so unexpected and so out of context that many thought it was a mirage. The owners of the fairy tale mansion, Harman and Margaret Blennerhassett, called their enchanted island the "Isle de Beau Pre" because of its beautiful meadows. Stunned river travelers simply called it Eden.

Tales of the magical island spread from the American frontier to the drawing rooms of London and Madrid. But it wasn't long before conversations about this island shifted away from the beautiful house, the lovely gardens and the Blennerhassetts' genteel lifestyle. People began whispering about much darker matters: treachery, conspiracy, incest and treason.

A Perfectly Lovely Couple

Harman and Margaret Blennerhassett arrived in Marietta in the fall of 1797. The aristocratic newlyweds, who had emigrated from Ireland, found a warm welcome on the frontier. The citizens of Marietta did their best to convince the Blennerhassetts to forget their plan to settle in Tennessee. They encouraged the sophisticated and fabulously wealthy couple to become residents of Marietta. It's unlikely they would have

been as enthusiastic about the newcomers if they had known why the couple left Europe.

Margaret was not just Harman Blennerhassett's wife; she was his niece, his sister's daughter. Their sudden, incestuous marriage had shattered their family, outraged the church and horrified polite society. If that weren't enough, Harman was committed to the cause of Irish independence and had openly engaged in activities the British government considered treasonous. In 1796—the year Harman and Margaret married—rumors of Harman's imminent arrest swirled through the Irish countryside. The Blennerhassetts may have been on the wrong side of the government, the wrong side of the church and without friends, family or allies, but all was not lost. Harman still had access to his family's fortune.

The newlyweds descended upon London and began to shop. They purchased bolts of wool; yards of silk; boots, shoes, stockings and hats; an iron cauldron; fourteen pink china plates with gold rims; dresses, underwear, nightgowns and coats; oil paintings; Oriental rugs; statues; hundreds of books; casks of wine; wheels of cheese; medical supplies; guns; and a state-of-the-art telescope. When they were confident they had everything they could conceivably need, they loaded it all onto a ship bound for America. Harman and Margaret corralled their servants, including a full-time gardener, and left the threats, problems and negative judgments of the Old World behind.

Much to the delight of many in Marietta, the Blennerhassetts decided to stay in the area. The couple began searching for the perfect spot to build their new home, but nothing seemed right. An acquaintance suggested they visit his island in the Ohio River about fourteen miles downstream from Marietta. On a warm autumn afternoon, they boarded a small boat for a leisurely trip down the river. Even before they stepped ashore, Harman and Margaret were under the island's spell. They strolled on a carpet of golden leaves and marveled at the primeval trees filled with chattering, leaping squirrels. Each time they grew silent, they heard birdsong, buzzing insects and the soothing lap of small waves. It all seemed so exotic, so different from the world they knew. They stood on a rise facing east, upriver toward Marietta, and agreed that their search was over.

When the couple realized the island was part of Virginia, not Ohio, which meant they could own slaves, it seemed that everything had finally fallen into place. Within a few months, Harman and Margaret were living in a rough blockhouse on the island, overseeing construction of their mansion. It would come to be known as the most spectacular house west of the Allegheny Mountains.

Blennerhassett Island

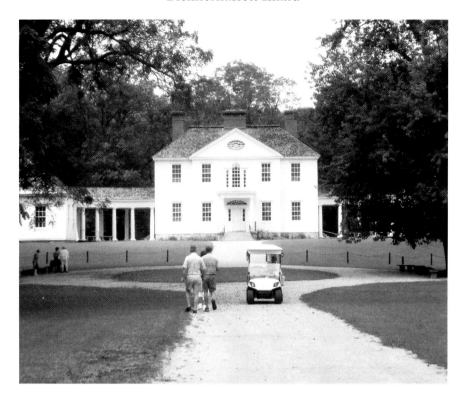

The reconstructed mansion on Blennerhassett Island. *Photo by Michael Pingrey.*

The mansion was completed in 1800 at a cost of more than $40,000, about $500,000 in today's dollars. The elegant Palladian design included a twelve-room central structure two and a half stories tall with twin porticoes that curved away from the main house. Each portico led to a one-and-a-half-story structure called a wing building. One wing building served as Harman's office; the other contained the summer kitchen and servants' quarters. The Blennerhassetts filled their home with the treasures they had obtained in London. By all accounts, the house was lovely—opulent yet tasteful.

The mansion was surrounded by formal gardens complete with winding gravel paths, benches, rose bushes and fragrant vines. Cattle grazed in the five acres of lush, green grass that stretched from the house to the banks of the Ohio. There was even a large hothouse where the Blennerhassetts' English gardener tended orchids and harvested oranges, lemons and figs.

The island quickly became a glittering outpost of culture, sophistication and style. Receiving an invitation to Blennerhassett Island, as it had come

to be known, was a sure sign that a lady or gentleman had reached the pinnacle of society. Harman and Margaret hosted an endless series of balls, costume parties, formal dinners and concerts. Guests who preferred quieter forms of entertainment played cards, perused the couple's impressive library or wandered through the estate's gardens in the moonlight. Harman and Margaret led a charmed existence on their magical island. Or so it seemed to those who came to dance the night away.

But the carefully constructed façade of the Blennerhassetts' lives was crumbling. Harman was an intelligent man, a gifted musician and a wonderful host. Gullible, sentimental and idealistic, he was also an easy mark for con men and swindlers. He had squandered a fortune via poor investments and disastrous business deals. His financial mismanagement coupled with Margaret's extravagant spending caught up with them in 1805. Only five years after they moved into their mansion, the Blennerhassetts realized they could no longer afford their island paradise.

After much discussion and anguish, the couple decided to sell their island estate and move south to the Louisiana Territory, where Harman believed he had a better chance of earning a reasonable income. They agreed to keep their financial difficulties to themselves until they found a buyer.

Lack of money wasn't the only factor that played into Harman and Margaret's decision to leave. Stories of the fabulous mansion in the wilderness and its gracious owners had spread to the East Coast and beyond. A trickle of visitors had begun arriving from Ireland. It was just a matter of time before someone who knew that the Blennerhassetts' marriage was incestuous arrived. If Harman and Margaret's new friends and neighbors learned their secret, they would become social outcasts again. But that wasn't their greatest fear. While living on the island, the Blennerhassetts had become parents, and they were determined to conceal the truth about their relationship from their children at any cost.

Margaret continued to play her role as the cultured and wealthy hostess, while her husband struggled with their overwhelming financial problems. On a balmy spring evening in 1805, an unexpected visitor knocked on the mansion's front door and inserted himself into the Blennerhassetts' volatile, emotionally draining situation. The visitor was not an Irish relative as they had feared. It was none other than Aaron Burr, the charismatic former vice president of the United States and the most despised man in America.

Blennerhassett Island

A Foolproof Plan

Aaron Burr had been a rising political star. He was a brilliant lawyer who had served as U.S. senator from New York, as well as vice president during Thomas Jefferson's first term. It all fell apart in 1804, when—while vice president—Burr killed Alexander Hamilton in a duel. Although dueling was fairly common at the time, Burr was indicted for murder. Jefferson, who despised Burr, insisted that the vice president step down. The murder charges were eventually dropped, but Aaron Burr's career was over, at least as far as the eastern political establishment was concerned. His reputation in tatters, Burr decided to try his luck on the frontier.

In 1805, Burr traveled to Pittsburgh, boarded a specially outfitted boat that he called his "Ark" and set sail down the Ohio. He spent some time in Marietta, where he toured the ancient earthworks, charmed the ladies and hobnobbed with local politicians. Burr thrived on gossip, and by the time he met Harman Blennerhassett, who was in Marietta pursuing one of his far-fetched business schemes, Burr already knew all about the fabulously wealthy couple and their extravagant lifestyle.

A few days later, Burr left Marietta to continue his voyage into the interior. His Ark arrived at Blennerhassett Island around sunset. Even though he did not have an invitation to call, he stepped ashore, walked up to the mansion's front door and presented himself. Harman and Margaret, always the gracious host and hostess, welcomed the former vice president to their home. Over an elegant dinner, Aaron Burr and Harman Blennerhassett discovered they had much in common. The two sat up talking well into the night.

Burr confided that he was raising a private army to invade and seize the Spanish-held territories of Texas and northern Mexico. When the shooting stopped, Burr planned to declare himself the benevolent emperor of a new independent country. He assured Blennerhassett that his plan was not only well thought out but also foolproof. He further stated that those who rallied to his cause would be rewarded with land, riches and prestige. During their long conversation, Burr even mused that Harman would make an excellent ambassador to England. There was just one slight obstacle, one small hurdle that stood in the way of total success: money.

The idealistic and gullible Harman Blennerhassett wanted desperately to be involved in Burr's adventure. He pledged his full support without revealing how shaky his own financial situation was. Harman readily agreed when Burr suggested they stockpile supplies on the island. By the end of the evening, they had decided that Blennerhassett Island

would serve as the expedition's headquarters, and the invasion would be launched from there.

The next morning, Burr continued his journey, stirring up anti-Spanish sentiments as he slowly made his way south and west. Attracting supporters was much easier than even the ever-confident Burr had anticipated. Frontier settlers perceived Spain as a direct threat to their survival. In 1802, Spain had closed the port of New Orleans to American shipping. Westerners had urged President Jefferson to respond by declaring war and annexing the Spanish territories of Florida and Texas. Even though that crisis had been resolved peacefully and the United States had since acquired New Orleans as part of the Louisiana Purchase, residents were very interested in Burr's invasion plans. The eastern establishment may have dismissed the former vice president as a disgraced has-been, but the westerners saw him as a patriotic hero ready to lead them against the tyranny of the Spanish crown.

As Burr wound his way ever deeper into the American wilderness, preparations for the invasion progressed. He sent an order to shipwrights in Marietta for fifteen boats, ten of them forty feet long and five fifty feet long. He intended to use the vessels to transport troops. In the meantime, Harman Blennerhassett got busy laying in huge quantities of flour, corn, bacon and whiskey.

Things Fall Apart

Not everyone who heard about Burr's expedition was enthralled with the idea. Reports of his plans began to reach President Jefferson. As a private citizen, Burr did not have the right to invade a foreign country. That much was clear. But many of Burr's enemies thought something more dangerous was afoot. They did not believe he actually planned to invade Texas and Mexico. They suspected his real target was New Orleans. According to their theory, once he captured the city, he'd establish it as the capital of a new country made up of the frontier states and western territories, whose citizens would rise up and secede from the United States on his orders. There was no evidence to support this theory. Nevertheless, President Jefferson was becoming uneasy. So were many residents of the Ohio Valley. A network of political informants—including Thomas Jefferson's friends and supporters the Henderson brothers, who lived on the edge of Williamstown—began quietly keeping a wary eye on Blennerhassett Island.

When troops began gathering on the island, the residents on the Virginia side of the Ohio River called an emergency mass meeting. They passed resolutions against Burr and the Blennerhassetts and called for volunteers

to defend the public in case of an attack from the island. The resolutions appeared in the local papers and were forwarded to the White House. Thomas Jefferson sent an undercover agent to Marietta to investigate.

After receiving the agent's report, Jefferson issued an order to all civil and military authorities to arrest the participants in Burr's expedition. The governor of Ohio impounded Burr's boats, which were still in Marietta, while the Virginia militia prepared to storm the island and arrest everyone in sight. A few of the rowdier militia members boasted that they intended to kill Harman and burn his mansion to the ground. Word of what was coming reached the Blennerhassetts. As soon as it was dark, Harman said goodbye to his wife and young sons, boarded a small boat and quietly headed downstream to join Burr, who was somewhere in Kentucky.

The next morning, Margaret took the children to Marietta to board the boat that Burr had commissioned for the family. However, she was informed that the vessel had been seized, along with all the others. She returned to the island, only to find her home occupied by the Virginia militia. After drinking everything in the Blennerhassetts' wine cellar, the Virginians had indulged in an orgy of destruction. They broke the windows, shattered the gilded mirrors, ripped down the curtains, tore doors off their hinges, smashed the pink china and threw Margaret's priceless alabaster vases against the fireplace mantles. They fired their rifles through the ceilings and snapped the elegant curved legs off the tables and used them for kindling in the bonfire they set on the front lawn.

The leader of the militia allowed Margaret to salvage a few papers, books and personal mementos from the house. Then she and her children boarded a boat filled with young men from Pittsburgh, whom the militia had briefly detained thinking they were part of Burr's army, and fled west. She never saw the island again.

The authorities caught up with Harman Blennerhassett and Aaron Burr in the Mississippi Territory a few months later. Both were arrested and charged with treason. Since the crime was allegedly committed on Blennerhasset Island in Virginia, they were taken to Richmond and imprisoned in the state penitentiary. The trial of Aaron Burr, the most sensational political trial in American history, began in late May 1807. Harman Blennerhassett's neighbors, Alexander and John Henderson, testified against the former vice president. Nevertheless, Aaron Burr was acquitted in September. The charges against Harman Blennerhassett were dropped. After his release from prison, he traveled south to join Margaret and their children in the Mississippi Territory.

The Blennerhassetts spent the rest of their lives struggling to reestablish themselves and recover financially. They never succeeded. The couple eventually moved to England, where Harman's sister supported them. They later moved to the Island of Guernsey, where Harman died in 1831. Margaret returned to the United States and died in New York City in 1842. Her cause of death is unknown. Their children didn't fare much better. Three boys grew to adulthood. One died from cholera; another drank himself into an early grave. The youngest son married and had two children, but both died in childhood. When he passed away at the age of fifty, Harman and Margaret's line died with him.

The enchanted island went into decline, too. After Margaret's departure in 1806, Virginia authorities sold off what remained of the Blennerhassetts' possessions to pay back taxes. A few years later, in 1811, the mansion was destroyed by fire. The only evidence that remained of the Blennerhassetts' extravagant lifestyle was in the hands of those who had purchased their belongings at the tax auction. Several of those items are on display in the Campus Martius Museum in Marietta.

After the Blennerhassetts' departure, a number of people—most of them farmers—called the island home. It also became a popular spot for picnicking and swimming. During the Victorian era, the island briefly served as an amusement park complete with a boxing ring, baseball diamonds and a dance pavilion that featured live music from dusk until dawn. The great flood of 1913 submerged the island and put an end to commercial development. As saplings, weeds and vines slowly but surely took hold and spread, the island returned to a natural state.

In 1973, the State of West Virginia sent a team of archaeologists to perform a general survey of Blennerhassett Island. Their discoveries were nothing short of extraordinary. One group found the remains of a prehistoric village, and the other located the legendary mansion's foundations. In 1980, the island was opened to the public as Blennerhassett Island Historical State Park. In 1984, reconstruction of the Blennerhassett Mansion began. The house was completed in 1991. Investigation of the estate's gardens, grounds and outbuildings continues.

A particularly touching ceremony was held on the island in 1996. The remains of Margaret Blennerhassett and those of her son who died of cholera were removed from a mausoleum in New York City and returned to their beloved island. They were reinterred near the reconstructed mansion. Home at last.

In the two centuries that have passed since Aaron Burr's trial, hundreds of thousands of words have been written about the plot. Was Burr a traitor?

Many modern historians do not believe he had any intention of inciting westerners to secede. They think his enemies framed him. Others insist that the evidence clearly points to his guilt. The debate continues.

Burr's true motives are not the only mystery that hovers over the island. Every few years, rumors of a lost treasure circulate through the valley. Many believe Aaron Burr and Harman Blennerhassett stockpiled more than bacon and whiskey as they prepared for their great expedition. They maintain that wealthy supporters donated a fortune in gold to fund Burr's new government. The gold, along with a list of the contributors, was kept in a large wooden chest that was hidden in a secret underground location somewhere on the estate's grounds. In the chaos and confusion surrounding the Blennerhassetts' sudden departures, the treasure was left behind. If Harman and Margaret could have accessed it, their lives certainly would have been easier. In any case, the chest of gold is still missing.

The final mystery brings the story of the Blennerhassetts full circle. Each year, visitors, volunteers and those working on the island in various capacities encounter a ghost. To a person, they swear the apparition is Margaret Blennerhassett. Dressed in a long white gown, she stands in the walnut grove gazing toward her beloved mansion, seemingly unaware that others are present. Perhaps she has returned to the days before the arrival of Aaron Burr, when her children were young, her husband was a respected businessman, she was the belle of the ball and they lived in a fairy tale palace on an enchanted island.

Getting to the Island

Blennerhassett Island, the fifth largest in the Ohio River, is located one and a half miles downstream from Parkersburg, fourteen miles downstream from Marietta and parallel to Belpre, Ohio. Blennerhassett Island Historical State Park is open from early May through late October. Days and hours of operation vary by month and are subject to change.

The only way to reach the island is by boat. A replica of a Victorian-era riverboat carries passengers on a relaxing and nostalgic journey to and from the island. The boat normally departs from Point Park, a riverfront area in downtown Parkersburg, West Virginia, where the Little Kanawha River flows into the Ohio. However, Point Park is undergoing extensive renovations, which have caused the Blennerhassett Island boat to be temporarily moved to Belpre, Ohio. It departs from and returns to Civitan Park. Once the

A GUIDE TO HISTORIC MARIETTA, OHIO

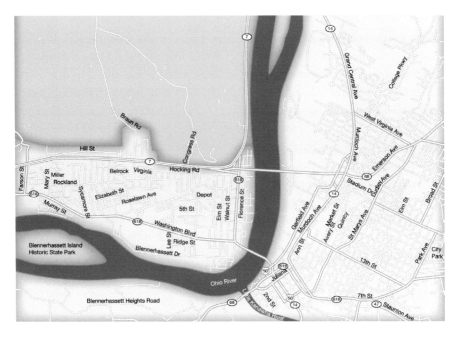

Belpre, Blennerhassett Island and Parkersburg map. *This image is copyrighted by the Marietta-Washington County Convention and Visitors Bureau and appears with the bureau's permission.*

Parkersburg renovations are complete, it will return to its regular location at Point Park. Please check the park's website for the boat's current location. For up-to-date information, including prices, days and hours of operation, boat location and schedule, special programs and museum information, visit www.blennerhassettislandstatepark.com or call 304-420-4800.

Directions from Marietta to the Civitan Park Boat Landing in Belpre, Ohio

Take Second or Third Street out of downtown Marietta to Washington Street.
Turn left on Washington Street. Take the Washington Street Bridge across the Muskingum River.
You are now on Ohio Route 7 South.
Follow Route 7 South to Belpre, eleven miles from Marietta.
When you reach Belpre, take the Parkersburg-Belpre exit on the right.
The exit ramp becomes Main Street, which is also Route 618.
Stay on 618 as it turns right off Main and becomes Washington Boulevard .
Follow Washington Boulevard about one mile to the Lee Street intersection.
 There is a traffic light.

Blennerhassett Island

Turn left on Lee.
Follow Lee to Blennerhassett Avenue. Turn right and continue to Civitan Park. Turn left into the parking lot at the sign that says, "Sternwheeler Landing." Civitan Park's address is 1500 Blennerhassett Avenue.

Directions from Marietta to Point Park in Parkersburg, West Virginia

Take Second or Third Street out of downtown Marietta to Washington Street.
Turn left on Washington Street. Take the Washington Street Bridge across the Muskingum River.
You are now on Ohio Route 7 South.
Follow Route 7 South to Belpre, eleven miles from Marietta.
When you reach Belpre, take the Parkersburg-Belpre exit on the right.
The exit ramp becomes Main Street, which is also Route 618.
Go through the light at the Washington Boulevard intersection, veer to the left and take the bridge across the Ohio River into Parkersburg.
Turn right on Juliana Street.

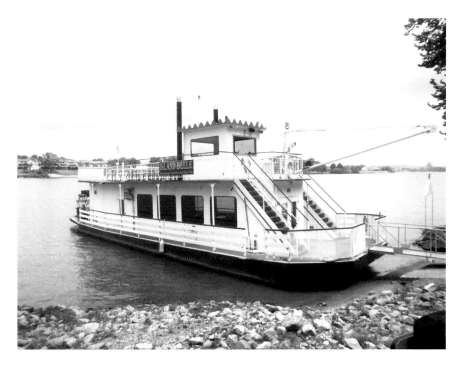

The only way to reach Blennerhassett Island is by boat. *Photo by Michael Pingrey.*

Turn right on Second Street.
Follow the signs to the Park.

The riverboat makes a round trip each hour. Tickets may be purchased on board. Again, please visit www.blennerhassettislandstatepark.com or call 304-420-4800 for up-to-date information on the riverboat's location and schedule.

Exploring the Island

One of the nicest aspects of visiting the island is the casual and unstructured nature of the whole experience. You have several options, including simply wandering the grounds and enjoying the atmosphere. Each component—boat ticket, mansion tour, wagon ride, bike rental—is sold separately. You can do as much or as little as you like, and you don't have to decide on the details until you arrive. Stay an hour or stay all day. It's up to you.

There are picnic tables and charcoal grills under the trees, as well as plenty of places to relax and watch the river go by. Visitor facilities include public restrooms, a gift shop and a concession stand with cold drinks, ice cream and other snacks. You may bring your own food and beverages to the island. Alcohol, however, is not permitted. Leashed pets are welcome, but not in the mansion.

History buffs will want to tour the reconstructed mansion. Guides in period dress tell the Blennerhassett story as they point out the interesting features of the house. The center section of the mansion contains twelve exquisite rooms decorated as they were when the island was the hub of social activity in the area. Many visitors are surprised by the bright wallpaper and vivid colors that were in style during the early 1800s. The curved porticoes and both wing buildings are included on the tour. The northern wing, which served as Harman's study and office, is filled with books, scientific devices and musical instruments. The southern wing, the summer kitchen, showcases a fascinating collection of early American utensils and kitchen tools. The Blennerhassetts' servants lived above the summer kitchen. The family also owned an unknown number of slaves. Their quarters have not yet been located.

The estate was famous for its elaborate gardens. Some were formal affairs with paths, manicured hedges and exotic flowering shrubs. Others provided

vegetables, as well as medicinal and culinary herbs. Historians plan to eventually re-create the grounds. Archaeological investigations on the island continue, and each year new pieces of the puzzle emerge.

The horse-drawn wagon ride around the island is highly recommended. The island is quite large, and most of it is undeveloped. It has become a refuge for song birds, waterfowl, deer and other small animals, just as it was when Harman and Margaret saw it the first time. The driver points out interesting features, as well as reclusive wildlife. For most of the ride, however, passengers are left with their own thoughts as the wagon rolls through grassy meadows and past groves of enormous trees. The peaceful journey is accompanied by chirping birds, rustling leaves and the soft thudding of hooves on the dirt path. Those who prefer to explore the island under their own power can rent bicycles by the hour or half hour. Small (twenty-inch) bikes are available for kids.

The Blennerhassett Mansion is not the only significant structure. The Putnam-Houser House, which was moved to the island from Belpre, Ohio, sits a short distance from the main house. Maple Shade, as it was originally known, was built in 1802. Although no match for the grand mansion, in its day, Maple Shade was one of the finest homes on the frontier. Seven generations of the Putnam family lived in the house. When the last member died in the early 1980s, the house was in very poor condition and was scheduled for demolition. The Shell Chemical Company stepped in, bought the building and had it moved to Blennerhassett Island. It has since been restored and is open to visitors.

Special events are held on the island throughout the season, including dinners, luncheons and candlelight tours of the mansion. Groups of ten or more may qualify for discounts, and the riverboat is available for private charters.

The Blennerhassett Museum—Parkersburg, West Virginia

The Blennerhassett Museum of Regional History is located on the corner of Second and Juliana Streets in downtown Parkersburg. It features a nineteenth-century collection of stone artifacts from the island's prehistoric past. Archaeologists believe people may have lived on the island as early as 9000 BCE. Native Americans were certainly there during historical times. The Blennerhassetts often presented their visitors with arrowheads, flint

axes and other relics unearthed on their property. Museum visitors may also watch a video about the Blennerhassetts and the Burr conspiracy. A separate entrance fee is charged. The museum is open year-round. Call 304-420-4800 or visit www.blennerhassettislandstatepark.com for more information.

Acknowledgements

Thanks to the Marietta–Washington County Convention and Visitors Bureau for allowing me to use its copyrighted maps. I also thank the Washington County Public Library, Genealogy and Local History branch, and the Washington County Historical Society for granting access to their picture collections. I extend a very special thank you to Kerri Griffith at Fenton Art Glass for sharing information on the history of the company and of Williamstown. And last, but certainly not least, I wish to thank my husband, Michael Pingrey, for his beautiful photos.

Bibliography

Burke, Henry Robert, and Charles Hart Fogle. *Images of America—Washington County Underground Railroad*. Charleston, SC: Arcadia Publishing, 2004.
Century Review of Marietta, Ohio. Marietta, OH: Marietta Board of Trade, 1900.
Clark, Katherine L., ed. *Reflections of the Past*. Marietta, OH: Marietta Bicentennial Commission, 1987.
Clayton, Andrew R.L., and Paula R. Riggs. *City into Town: The City of Marietta, Ohio, 1788–1988*. Marietta, OH: Marietta College Dawes Memorial Library, 1991.
Cottle, Elizabeth Stanton, ed. *A Window to Marietta*. Marietta, OH: American Association of University Women, 1996.
Hawley, Owen. *Mound Cemetery Marietta, Ohio*. Marietta, OH: Washington County Historical Society, Inc., 1996.
Lepper, Bradley T. *Ohio Archeology: An Illustrated Chronicle of Ohio's Ancient American Indian Cultures*. Wilmington, OH: Orange Frazer Press, 2004.
Measell, James, ed. *Fruitful Valley Revisited: A Chronicle of Williamstown, West Virginia*. Williamstown, WV: Williamstown Historical Committee, 2003.
O'Donnell, James H. *Ohio's First Peoples*. Athens: Ohio University Press, 2004.
Schneider, Norris F. *Blennerhassett Island and the Burr Conspiracy*. Columbus: Ohio Historical Society, 1966.
Smith, Art, ed. *A Picturesque Past*. Marietta, OH: Marietta Times, 2001.
Sturtevant, Lynne. *Haunted Marietta: History and Mystery in Ohio's Oldest City*. Charleston, SC: The History Press, 2010.

BIBLIOGRAPHY

Summers, Thomas J. *History of Marietta Ohio*. Marietta, OH: Thomas J. Summers, 1903.

Swick, Ray. *An Island Called Eden*. Parkersburg, WV: Ray Swick, 1995.

Swick, Ray, and Christina Little. *Images of America—Blennerhassett Island*. Charleston, SC: Arcadia Publishing, 2005.

White, Larry Nash, and Emily Blankenship White. *Images of America—Marietta*. Charleston, SC: Arcadia Publishing, 2004.

Williams, Gary S. *Gliding to a Better Place*. Caldwell, OH: Buckeye Books, 2000.

Woodward, Susan L., and Jerry N. McDonald. *Indian Mounds of the Middle Ohio Valley: A Guide to Adena and Ohio Hopewell Sites*. Newark, OH: McDonald and Woodward Publishing Co., 1986.

Index

A

Adelphia 14
Adena 15, 35, 53, 58, 82, 91, 102
Adventure Galley 14
Alpha Xi Delta Sorority House 80
Anchorage 22, 24, 53, 73, 96, 114
Anderson Hancock Planetarium 79
Andrews Hall 79
Antoinette, Marie 14, 72
Auditorium 52

B

Battle of Fallen Timbers 17
Battle of Penobscot Bay 84
Bellevue Hotel 36, 40
Belpre 24, 106, 107, 129, 133
Belpre Historical Society 106
Betsey Mills Club 98
Bicentennial Plaza 30
Blennerhassett, Harman 113, 122, 125, 126, 127
Blennerhassett Island 121, 125, 128, 129

Blennerhassett Mansion 102, 128, 133
Blennerhassett, Margaret 121, 129
Blennerhassett Museum of Regional History 102, 133
Borglum, Gutzon 58
Bosley, Stewart and Bertalyn 97
Brass Sidewalk Letters 41
Buckley House 63
Buckley's Island 32
Burr, Aaron 113, 125, 127
Busy Bee Restaurant 70

C

Campus Martius fort 100
Campus Martius Museum 17, 100, 128
Capitoleum 15, 92
Castle 53, 73, 81, 96, 114
Colony Theatre 51
Conus 15, 81, 83, 86, 91
Cotton House 89
Covered Bridge Scenic Byway 107
Cutler, Ephraim 23

INDEX

D

David Putnam House 68
Dawes, Charles Gates 93
Dawes House 93
Dawes, Rufus 93
de Bobula, Titus 95
Douglas Pattin House 69

E

Edwards, Tommy 94
Ely Chapman Center 98
Erwin Hall 79

F

Farmers' Castle Museum and Education Center 106
Fearing House 71
Fenton Art Glass 116, 119
Fenton, Frank and John 116
First Baptist Church 98
First Congregational Church 62
First Presbyterian Church 96
Fort Harmar 14, 17, 19, 65, 73
French and Indian War 13, 20, 111
French Monument 72
Front Street 19, 22, 28, 35, 37, 39, 58, 60

G

Galley Restaurant and the Adelphia 56
Goose Creek 56

H

Hackett Hotel 56
Harmar 66, 104, 111
Harmar Cemetery 74
Harmar, Josiah 65
Harmar Post Office 71
Harmar Railroad Bridge 66

Harmar Tavern 69
Heart, Jonathan 14, 93
Henderson, George Washington 24, 113
Henderson Hall 73, 96, 111, 114, 119
high-water marks 42
Hippodrome Theatre 51
Hopewell 15, 21, 35, 53, 58, 90, 91, 92, 93, 102
House of Seven Porches 81
House on Harmar Hill 76

I

Indian Wars 36, 101, 106

J

Jefferson, Thomas 14, 21, 113, 125

K

Knox Boatyard 72

L

Lafayette Hotel 14, 17, 30, 35
Levee 29
Levee House Café 31
Levi Barber House 68
Lockmaster's House 45
Lookout Point 76

M

Marietta College 24, 77, 90
Marietta College Legacy Library 79
Marietta College President's House 80
Marietta Soda Pop Museum 69
Marietta–Washington County Convention and Visitors Bureau 30, 67, 108

INDEX

Marietta Wine Cellars 35
Masonic Temple 62
Meigs House 62
Meigs, Return Jonathan, Jr. 62, 88
Mills, Betsey 99
Mound Cemetery 21, 81, 86
MOVP Theater 51
Muskingum Academy 19, 78
Muskingum Park 58

O

Ohio Company 13, 17, 35, 56, 65, 81, 86, 100, 103, 112
Ohio Company Land Office 17, 100
Ohio National Guard 44
Ohio National Guard Armory 44
Ohio River Islands National Wildlife Refuge 103, 111, 118, 120
Ohio River Museum 100, 102
Ohio River Scenic Byway 107, 110
Ohio Street 21, 30, 37
Open Door Baptist Church 73

P

Penn Station 55
Peoples Mortuary Museum 63
Picketed Point 17, 36
Plumbers and Pipefitters Union Hall 43
Putnam, David 24, 114
Putnam, Eliza 73
Putnam, Rufus 13, 16, 21, 23, 25, 35, 56, 79, 84, 86, 90, 102, 103
Putnam Theater 51

Q

Quadranou 15, 92

R

Riley, Colonel 57
Rinky Dinks Flea Market 75
Riverview Building 40
Rouse, Bathsheba 106
Rufus Putnam house 100

S

Sacra Via 15, 21, 92
Saltonstall, Nathaniel 84, 87
Seneca Oil 25
Seventh-Day Adventist Church 94
Shipman and Holden Houses 63
Shipman-Mills House 96
Slocomb, John 22, 53, 54, 73, 81, 96, 114
Sons and Daughters of Pioneer Rivermen 103
Spagna's Restaurant 70
St. Clair 20
St. Clair, Arthur 60
St. Clair Building 53
Sternwheel Festival 30
St. Luke's Episcopal Church 53, 54
St. Luke's Lutheran Church 97
St. Mary's Catholic Church 95
St. Mary's Rectory 94
St. Paul's Evangelical Church 81

T

Tell City 103
Tiber Way 56
Tomahawk claim 111
Tomlinson, Samuel 112
Toy and Doll Museum 71

U

Ulhrich, Emil 95
Underground Railroad 23, 74, 106, 114

INDEX

Union Depot 55
Unitarian church 53, 81, 88
U.S. Post Office 47

V

Valley Gem 100, 104
Veterans' Walk of Honor 45

W

Ward, Nahum 53, 88
Washington County Courthouse 48
Washington County Historical
 Society 71, 73
Washington County Public Library
 15, 91
Wayne National Forest 106, 110
Way West Monument 59
Whipple, Abraham 20, 84, 87
White, George 80
Williams, Isaac 111
Williams, Rebecca 113
Willow Island Power Plant 76, 110
W.P. Snyder Jr. 100, 103

ABOUT THE AUTHOR

Lynne Sturtevant is the owner of Hidden Marietta, a tour company focusing on the town's fascinating past. A dynamic and popular speaker, Ms. Sturtevant offers presentations and special programs throughout the year. She is also the author of *Haunted Marietta: History and Mystery in Ohio's Oldest City*, available at fine shops and online. For more information or to contact the author, visit www.hiddenmarietta.com or www.facebook.com/pages/Hidden-Marietta.

Lynne Sturtevant in the Colony Theatre. *Photo by Michael Pingrey.*

Visit us at
www.historypress.net